IMAGES
of America

GARY'S GLEN PARK

IMAGES
of America

GARY'S GLEN PARK

John C. Trafny

ARCADIA
PUBLISHING

Published by Arcadia Publishing
Charleston, South Carolina

Printed in the United States of America

Library of Congress Control Number: 2014940602

For all general information, please contact Arcadia Publishing:
Telephone 843-853-2070
Fax 843-853-0044
E-mail sales@arcadiapublishing.com
For customer service and orders:
Toll-Free 1-888-313-2665

Visit us on the Internet at www.arcadiapublishing.com

*To the World War II veterans of Gary, who gave the best years
of their lives to serve the nation in its time of greatest need*

CONTENTS

ACKNOWLEDGMENTS

Images of America: *Gary's Glen Park* would not have possible without the assistance of a number of people who provided their time, photographs, personal and historical information, and technical assistance. There were also a number of local historians whose excellent publications during the past few years became sources for this book.

First, I want to give my sincere thanks to Steve McShane, curator of the Calumet Regional Archives at Indiana University Northwest in Glen Park. He provided much-needed assistance in locating the sources from their vast collections that would become part of the book. Steve also gave of his time to scan many of the photographs that were used.

Thanks also go to those who loaned me the beautiful photographs on the parishes in Glen Park. Fr. Stephen Loncar, Order of Friars Minor Conventual (OFM Conv.), pastor of St. Joseph the Worker Parish, provided some excellent photographs of the church and historical information. Cheryl Andricks of St. Hedwig Parish in Gary found dozens of great old photographs of Holy Family Parish in East Glen Park. My cousin Thomas Trafny of Centerfield, Utah, provided needed names of businesses in the neighborhood.

I was able to obtain a great deal of background information on Glen Park through the research and publications of local historians. Dr. James B. Lane's work *The City of the Century*, as well as his book with Dr. Ron Cohen, *Gary: A Pictorial History*, were tremendous assets. My fellow alumnus of Emerson High School in Gary, Kendall F. Svengalis, author of *Gary: A Centennial Celebration*, helped in locating the names of neighborhood houses of worship.

Special thanks go out to my sister Diane Trafny-Greenwood for organizing and typing the captions and to my nephew Stephen Greenwood for his computer skills. Without their help, my hair would be even grayer.

A great thanks goes to my editor at Arcadia Publishing, Jesse Darland, for his help, guidance, and patience in making the book possible. And my gratitude goes to Kelsey Jones, also of Arcadia, who helped get me through the approval process.

I also thank Dr. Lance Trusty of Purdue University, my graduate professor, whose time and encouragement helped in the publication of my first book, Images of America: *The Polish Community of Gary*, back in 2001. Finally, no historical research can be perfect, and the author assumes full responsibility for any errors and omissions herein.

Unless otherwise noted, all images appear courtesy of the Calumet Regional Archives.

INTRODUCTION

The United States Steel Corporation (US Steel) established Gary, Indiana, in 1906. The company wanted to build a modern steel plant on the southern shore of Lake Michigan that was near railroad and shipping lines and close to Chicago, which had a large labor pool that would build and operate the mill. The new area south of the plant began as a company town similar to those found in Pennsylvania in the coal and steel centers. But over the next decade, the steel town developed into a modern, 20th-century city.

Gary became a city of neighborhoods, including the East Side, the Central District, and the West Side, which were parts of the town when it incorporated in 1906. On the East Side, one found many of the skilled craftsmen that operated and maintained the massive plant, while professionals, company officials, and supervisors resided in the affluent West Side. South of the Wabash Railroad tracks, in the Central District, one could find the common laborers, many of whom were European or African American. It was in this part of town that the notorious "Patch" was located. Gambling, saloons, and prostitution lured many of the single men there to spend their hard-earned money.

As the Steel City grew in population, other communities were annexed. The town of Miller along the lakefront, and the town of Tolleston to the southwest became part of the city. The largest area, located south of the Little Calumet River, was added in 1909. That section was Glen Park.

The Glen Park section was bordered on the north by the Little Calumet River. To the east was the town of Hobart, while the western border was Grant Street. At first, the southern boundary was Forty-fifth Avenue, but, in the 1920s, the city extended this section to Fifty-third Avenue. Most of the area was made up of small farms, as well as sand dunes, an oak forest, and swamps.

Once annexed, the Glen Park area became a new point of interest to realtors, investors, and those seeking to buy land and purchase homes. Sections were set aside for residential housing, while lots along Broadway and Ridge Road were marked for business.

By the late 1920s, Glen Park's population included a diverse group of families, having moved from the other areas of Gary and from Southern and Eastern Europe. The ethnic groups included Poles, Slovaks, Serbs, Russians, and Italians. Most were drawn here for jobs in the mills and the chance to own their own home away from the more populated north side of town.

Many of those who came to Glen Park were immigrants from Europe. Around 1900, in huge numbers, immigrants came to the United States either to gain a fresh start or to escape the tyranny they faced in their homelands. Others who came to Glen Park were first-generation American citizens—20-year-old children of immigrants.

A strong sense of family, culture, and tradition bound these ethnic groups together. They worked hard and toiled long hours in the mills to provide for their families. Some went out on their own and started their own small businesses, such as grocery stores, small clothing shops, hardware stores, and places to eat. A few started their own family taverns. Those early saloons often served as the neighborhood social center for various ethnic groups. In those early days, the tavern owner served as the banker and translator for many of the older immigrants, whose English was often limited. They cashed their paychecks there, not in the city banks, as they wanted to deal with someone they trusted. In return, the saloon keeper knew he had loyal customers who spent money in his establishment.

Another, smaller, wave of immigrants came to Glen Park after World War II. They were refugees who had been taken by force to work in Germany as forced laborers. They did not want to return to their European homes, as the Soviet Union, under Joseph Stalin, had put their old homelands

under a totalitarian government. These displaced persons (DPs) were allowed to enter the United States during the postwar years by asking for asylum or having a family member sponsor them.

In addition to having strong family ties and solid work ethics, Glen Park residents were very religious. They thanked God in good times and asked for strength and health in bad times. Roman Catholics, members of the Russian and Serbian Orthodox Churches, and Protestants of various denominations established places of worship in the community to meet the spiritual needs of the faithful. Congregations raised their own money and built beautiful churches throughout the neighborhood. Volunteers gave their time to do work on the churches' foundations, roofs, and electrical work. Others put in the plumbing systems, pews, or stained-glass windows. Local contractors often donated the steel and bricks.

Catholics built Holy Family Parish, St. Mark's, St. Joseph the Worker, and Blessed Sacrament Church. The Russian Orthodox congregation established St. Mary's, and the Serbian Orthodox faithful erected St. Elijah Church. Protestant congregations built churches as well, including Glen Park Christian Church, Forty-third Avenue Presbyterian, Glen Park Baptist, Grace Methodist, and Emmanuel Lutheran Church. Others were Our Savior Lutheran, Glen Park Assembly of God, and the Glen Park Christian Church.

Catholic parishes in Glen Park also started their own elementary schools. For the immigrants that sent their children there, the schools helped the students continue their faith and preserve their culture and traditions. It helped that the nuns often spoke Polish or Croatian. However, the schools were not meant to separate the children from American society. Instead, they were started to help students assimilate into the American way of life.

Education was very important to everyone in Glen Park, not just Catholics. Immigrant and native-born parents believed that their children could have a better future if they stayed in school. Gary public schools helped students prepare for the future through academics and also provided many students with a skill, through shop classes, for boys, or domestic science, for girls. From the 1920s to the post–World War II years, most graduates went off to the local mills for employment and landed good-paying jobs. However, by the 1950s, that began to change in this blue-collar region, in part because of the GI Bill. Returning veterans were able to take advantage of the opportunity for a college education, courtesy of Uncle Sam.

The Gary Public School System built a number of elementary schools, starting with Glen Park School. Later, Lew Wallace High School was erected. It followed the curriculum set by Dr. William Wirt, which prepared all students with a well-rounded education.

Like the other Gary schools, Lew Wallace had an excellent group of teachers and a fine sports program, especially in football and baseball. Its 1941 varsity football team went undefeated and won the state title. The 1966 club went 10-0 and achieved a final ranking of number two in the state.

In the 1950s and early 1960s, new subdivisions were constructed south of Forty-seventh Avenue with modern brick ranch homes, making Glen Park a suburban-type area within the city. New businesses were established or expanded, while a modern shopping center was built on Grant Street. The postwar boom of the 1950s also saw the birth of the new campus of Indiana University Northwest at 3400 Broadway.

By the 1970s, the Glen Park neighborhood began to see a demographic change. Younger families settled in the suburbs, while older families left after retirement. The exodus even affected businesses, which left for the suburban malls. Crime, a huge downturn in the mills in the late 1970s, and a lack of city services changed the area in a dramatic way.

This book, however, is not meant to be a study of that change, as many urban areas saw a similar set of events. Instead, this book is a nostalgic journey back in time. It is a pictorial look at the neighborhood from 1908 to the 1980s. It is the author's hope that the reader, if they lived in the neighborhood, might see the images and recall fond memories of friends or events in their life. For others, maybe they will learn more about the community that their parents or grandparents grew up in. For those without those ties, it is hoped that they will still take this journey and learn more about Glen Park, the city of Gary, and their rich histories.

One

THE NEIGHBORHOOD

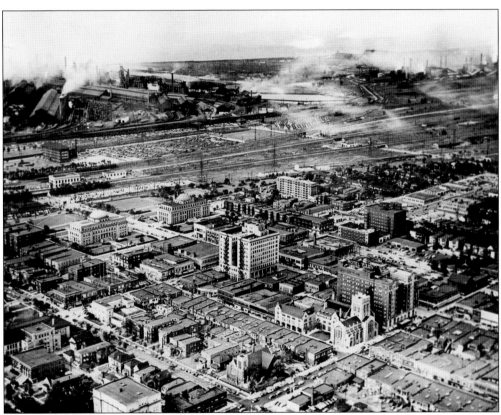

Gary, Indiana, once known as the "City of the Century," began with the construction of the modern steel plant by US Steel on the south end of Lake Michigan in 1906. Many only associate the "Steel City" with mills and its once-vibrant downtown. But it was more than that; it was a diverse population of hardworking men and women, many whom toiled in the "big mill" for long hours and low pay. It was also a city of neighborhoods, such as the East Side, Midtown, Miller, and the West Side. The largest was Glen Park, at the south end of the city.

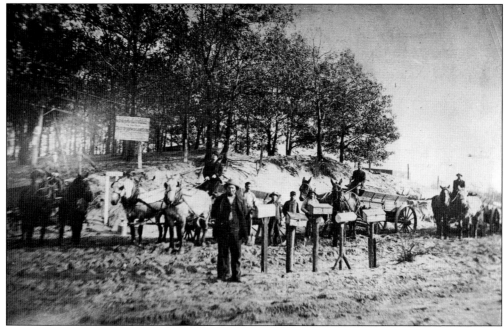

Ridge Road, part of an old Indian trail, was one of the main east-to-west routes across north Lake County. Much of the road ran along the ridge, which was formed by the Great Glacier when it receded north over 50,000 years ago and formed the Great Lakes. It was once part of the southern boundary of Lake Michigan. In this early photograph, taken in 1908, workers dig through a huge dune to extend the road that would be the main street of Glen Park—Broadway.

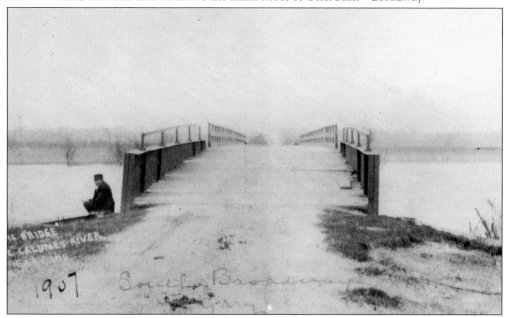

Before 1909, Gary's southern border was along the Little Calumet River, south of Twenty-fifth Avenue. That year, the city annexed the area as far as Forty-fifth Avenue. At the time, residents could only gain access to Glen Park via the bridges located at Broadway and Grant Street. Pictured is the Broadway crossing in 1907. The man at the left was probably trying his luck at fishing.

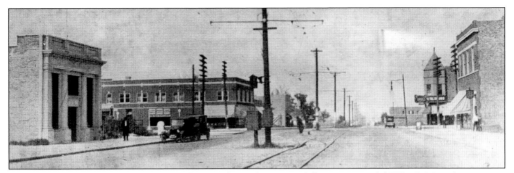

Gary and Glen Park saw continued growth in the years following World War I. New businesses continued to locate throughout the Steel City, as the population grew and new housing was available. Pictured are Ridge Road and Broadway in 1922. The building at the northwest corner housed the Glen Park Drugstore, Ridge Dry Goods, and the Harry Janos Restaurant. The new structure at the corner was the Glen Park State Bank. A trolley service was already available.

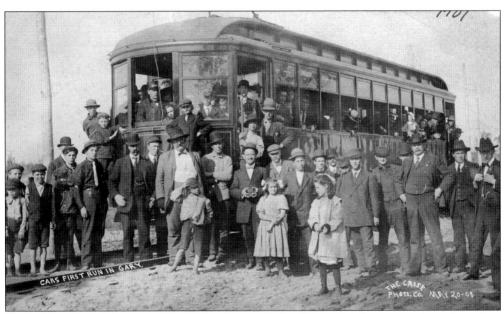

Once Broadway was extended south of Ridge Road, the Gary interurban system brought its line into the Glen Park area. The rails were laid, and trolley cars began to transport passengers to the downtown section of Gary, as well as workers to the US Steel plant along Lake Michigan. The system later connected Gary to communities such as Crown Point, Hobart, and Hammond. Pictured is a group of early passengers as they get ready to depart to their destinations. Trolleys continued until the 1930s, when buses began to replace them.

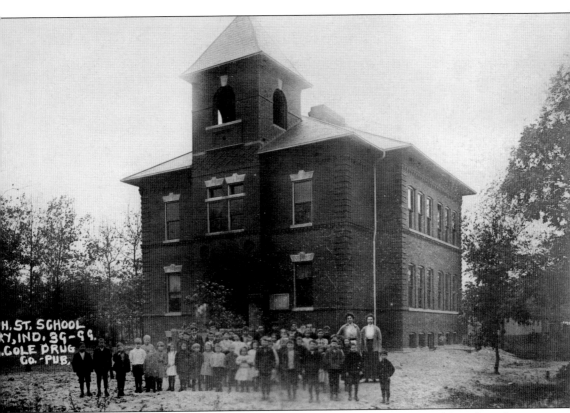

Glen Park School, located at the southwest corner of Thirty-ninth Street and Broadway, began during the fall of 1908. In this early photograph, students and faculty pose at the main entrance of the building. Originally named the Thirty-ninth Street School, it served as an elementary school. Looking closely, one can see that the area was still covered with sand dunes and oak trees, which were both common throughout the early years of the city.

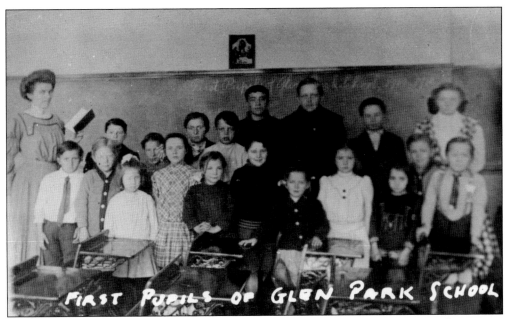

The first pupils of Glen Park School are pictured here during the 1909–1910 academic year. According to the information on the back of this photograph, the teacher was Mrs. William Watts. A Miss Ross was also mentioned. Students used textbooks, chalkboards, and the rote method, and teachers prepared students for the world of that era.

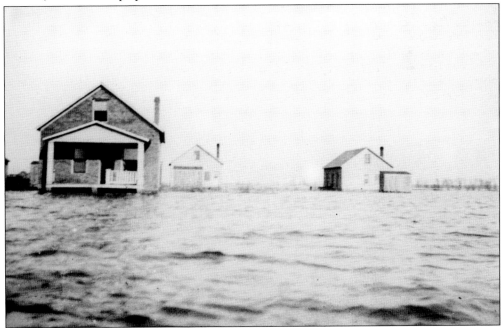

Residents of north Lake County recall the 100-year rains that caused devastating flood damage from Munster to Hobart along the Little Calumet River in 2006, and then again a few years later. The levies built for flood control were unable to do the job. Old-timers also have memories of previous floods that came every 10 to 15 years. Pictured is the flood of 1915 that hit Glen Park. In those days, federal aid was not yet available, and few residents were able to purchase insurance.

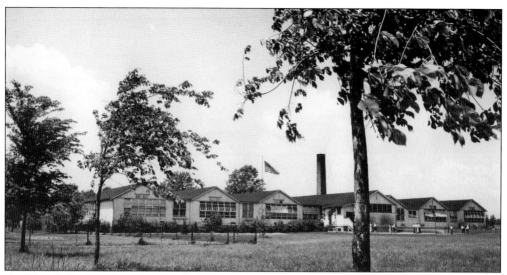

As Glen Park's population grew, the Gary Public School System constructed a new facility at Thirty-fifth Avenue and Delaware Street in 1924, Ben Franklin School. The first wooden structures were built on a brick foundation that housed the heating units. Four additional wooden portables were soon added for more classroom space that would be needed the following academic year. In addition to the classrooms, the buildings contained offices, an auditorium, a gym, a lunchroom, and a maintenance area. It is pictured here about 1925 with a view of the school's north side. The school is still in operation today, but the old portables were torn down years ago.

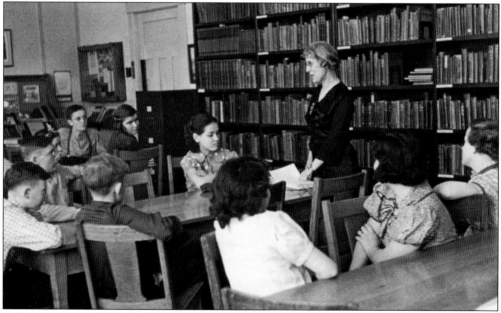

A few times a week, students of Franklin School met in the library for a storytelling period. A teacher or a member of the library staff would read from a selected work to the group. It was a time when reading was encouraged, and such gatherings were meant to help children love books at an early age. Though reading is still supported by many today, students face more distractions, such as computer games, online movies, or a lack of interest. In this picture, taken in the early 1930s, the librarian gives a presentation while the children give her their full attention.

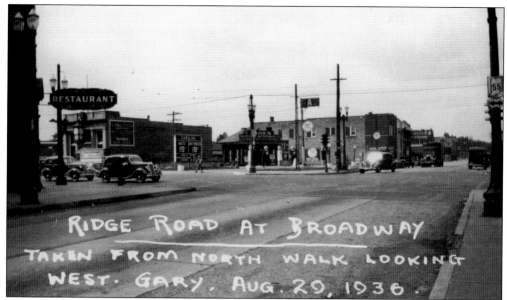

In 1936, residents were still facing economic challenges, making it hard to keep their homes, find a job, and have the cash needed to get by. However, many local businesses did manage to stay in operation. Pictured here is Ridge Road at Broadway looking west. The bank building at left was then a branch of the Gary National Bank, the only one to survive the stock market crash of 1929. The old Glen Park State Bank closed because it could not meet the new banking laws enacted by the New Deal to protect depositors.

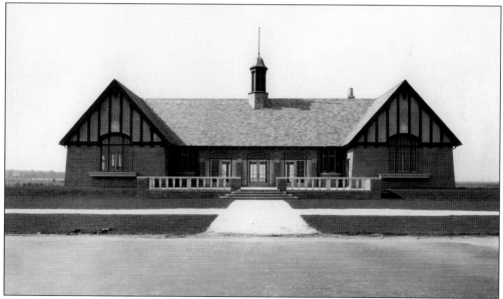

Municipal parks were set aside on city land throughout the city. At these parks, residents could relax, take part in community events, and even listen to concerts. For many residents that worked in the mills, the parks were a good place to cool off after 12 hours in the mills. In Glen Park, land was set aside for an 18-hole municipal golf course that would be open to Gary residents to enjoy. Pictured is the c. 1910 Gleason Park Golf Course Clubhouse, at Thirty-fourth and Jefferson Streets; the land had been recently cleared and laid out for eventual use.

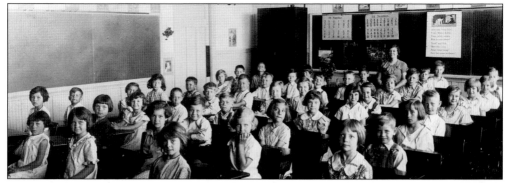

James Whitcomb Riley Elementary School, located at 1301 East Forty-third Avenue, was built to meet the growing population of Glen Park's southeast side. Though the families of the youngsters faced numerous hardships during the Great Depression, they made sure that their children attended school each day, and, if they did not attend each day, the truant officer paid them a visit. This photograph shows a typical classroom in 1934.

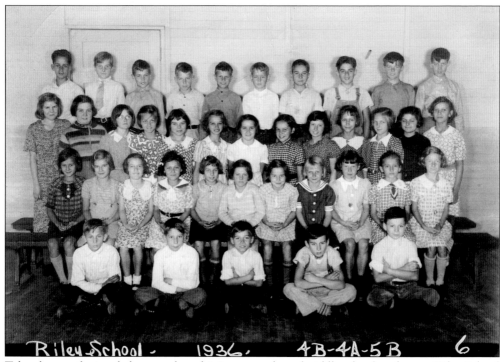

Taken by a professional photographer, this is a group shot of middle school students at Riley School in 1936. During World War II, many of the students would see their family members, relatives, or neighbors sent off to serve in the armed forces. Students usually helped by participating in scrap drives and rallies or sending care packages to soldiers overseas.

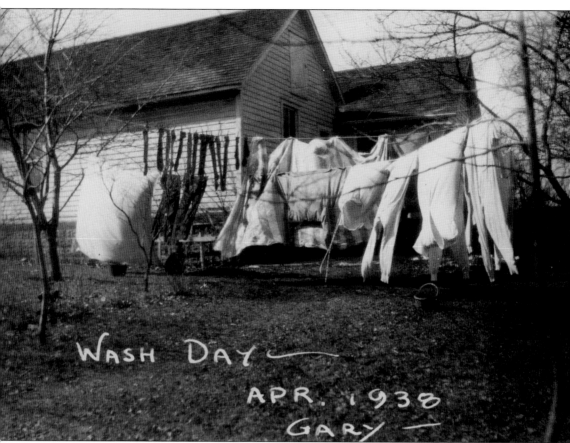

If it was Monday, it was wash day in West Glen Park. In 1938, before the era of automatic washers and dryers, women went to battle doing the laundry the old-fashioned way. They used manual machines, ran the clothes through the wringer, and then hung the clothes outside. On sunny days, the clothes dried in a few hours. However, housewives had to be on the alert for a change in the direction of the wind. If it shifted to the north, they would run out to the yard to quickly remove the clothes. The ore and coal dust from the mills could ruin a hard day's work. One could learn some pretty good curse words in various Eastern European languages when the wind shifted.

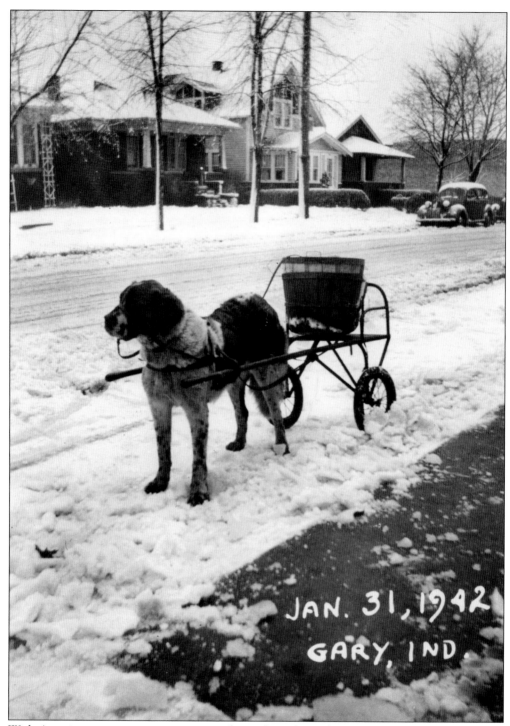

JAN. 31, 1942
GARY, IND.

With America at war, everyone was pressed into doing his or her part to assure victory over the Axis. In 1942, young men were leaving in increasing numbers to serve in the military. On the home front, women replaced men in business and industry, especially in defense plants. This 1942 photograph of a working pooch added a touch of old-fashioned patriotism.

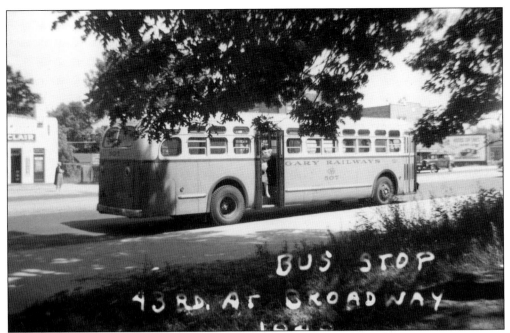

Public transportation in Gary underwent modernization in the 1930s. The old trolley line was gradually replaced with city buses. New local lines were added, and the old rails were removed or covered over by concrete. Pictured in this 1940 shot is a passenger stepping off at the stop at Forty-third Avenue and Broadway. In 2012, East Fifth Avenue was completely rebuilt. In the process, workers removed the trolley rails that had been buried in the old roadbed for over 70 years.

In 1926, the City of Gary annexed the land south of Forty-fifth Avenue to Fifty-third Avenue, which was later called Junedale. Most of the area was farmland, but, in the late 1950s and 1960s, modern, brick ranch houses were constructed to meet the housing needs of young families. Many of those building and buying these homes had served in World War II and/or the Korean War. Pictured is Broadway at Fifty-third Avenue, the city's border in the early 1950s.

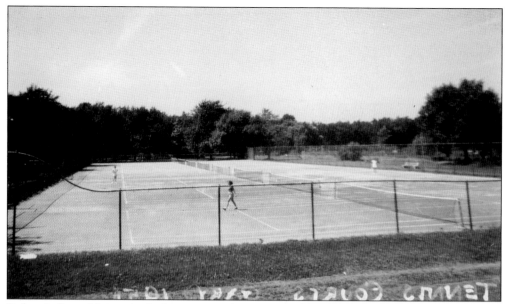

Before Indiana University built its regional campus in Glen Park, the area along Thirty-fifth Avenue and Broadway was under the direction of the Gary park system. Tennis courts, baseball diamonds, and park space for relaxation stood there. After the university purchased the land, the courts, baseball areas, and park space were relocated. The tennis courts that appear in this 1951 photograph were moved west of Gilroy Stadium in the 1960s.

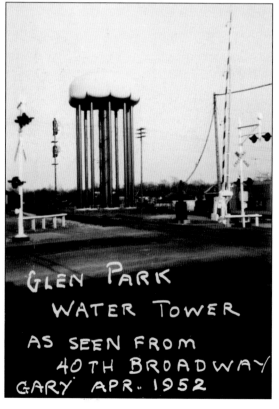

GLEN PARK
WATER TOWER
AS SEEN FROM
40TH BROADWAY
GARY APR. 1952

A Glen Park landmark that stood the test of time for many years since the Steel City's earliest days was the old water tower, located just east of Broadway near Forty-first Avenue. Built by the Gary Water Corporation, it supplied much-needed water for drinking and fire protection in the community. Another tower was constructed in the same style near Nineteenth and Adams Streets in Gary's Central District.

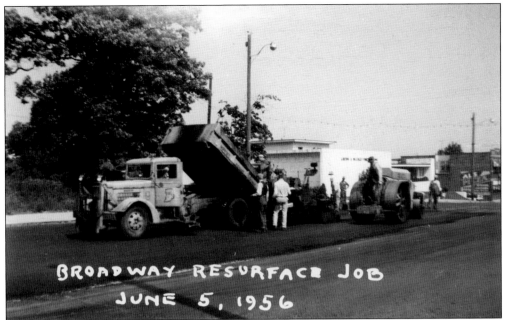

BROADWAY RESURFACE JOB
JUNE 5, 1956

Following World War II, Gary, along with the nation, went through an economic boom that lasted from 1945 through the 1960s. In 1956, when the Steel City was preparing for its golden jubilee, projects were underway, including repairs to the infrastructure. One large undertaking was the resurfacing of Broadway and other major arteries in every neighborhood. Here, workers spread a layer of asphalt along Forty-third Avenue and Broadway.

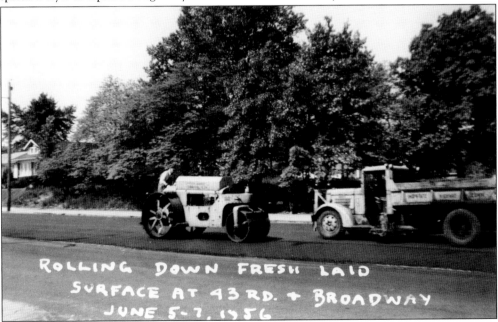

ROLLING DOWN FRESH LAID
SURFACE AT 43 RD. + BROADWAY
JUNE 5-7, 1956

Once the asphalt was spread, rollers were used to level the top layer to allow proper water runoff. Roadwork was a hot and dirty job for these crews. After work, members of the crew probably stopped by one of the local Glen Park watering holes to get a cold beer to cool off and wash the dust down.

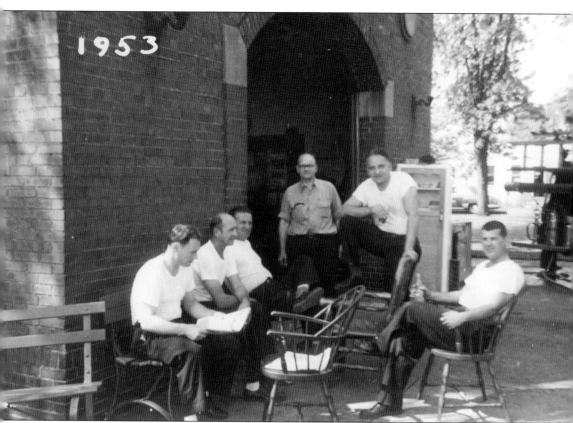

1953

Glen Park's oldest fire station, located at Forty-first Avenue and Washington Street, provides protection for the neighborhood and its residents. The structure was built in the 1920s and is still in operation as a fire station today. Pictured in 1953 is a group of firemen on break, waiting for the next call. It is possible that they just finished a friendly game of pinochle.

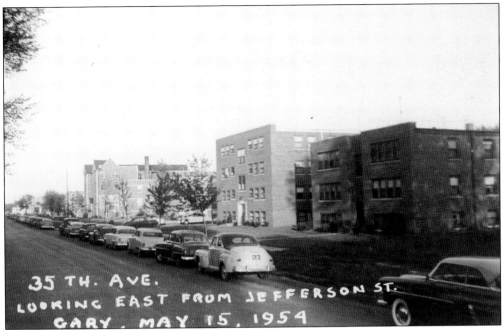

Numerous apartment buildings ran along Thirty-fifth Avenue from Broadway west to Pierce Street. On the north side of the avenue were Gleason Park and golf course and the future Indiana University Northwest campus. This 1954 photograph shows the apartments from Jefferson Street, looking east. In the 1970s, the university began to purchase these properties, as the school needed additional offices for the growing campus.

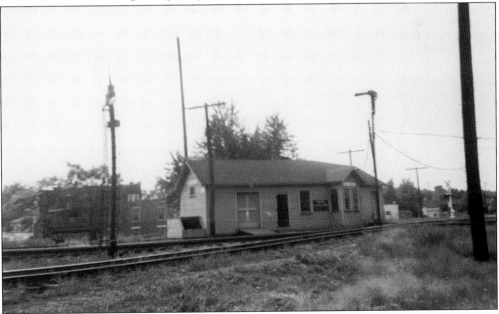

A long-forgotten structure in Glen Park was the old freight depot located just west of Fortieth Avenue and Broadway. The Nickel Plate line ran through the area beginning in the 1800s. It was still in use in the 1950s, when steam locomotives were being phased out for modern diesel-powered engines. The old depot was torn down some years ago. It is pictured here in 1957.

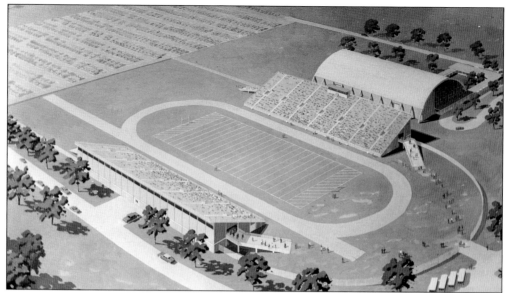

Architects Beine, Hall & Curran proposed the original design of Gary's Gilroy Stadium, located in Gleason Park. It was to coincide with the Steel City Golden Jubilee of 1956. It called for a two-sided stadium with a sports complex. The final plan never materialized, as escalating costs resulted in a much smaller facility. In 1957, Green Bay's Lambeau Field, home of the Packers, actually cost the Wisconsin taxpayers less money. In 1962, George Chacharis, the mayor at the time and a former city controller under Mayor Peter Mandich, was indicted and later convicted by the federal government for taking some $226,000 in kickbacks from local contractors involved in these construction projects.

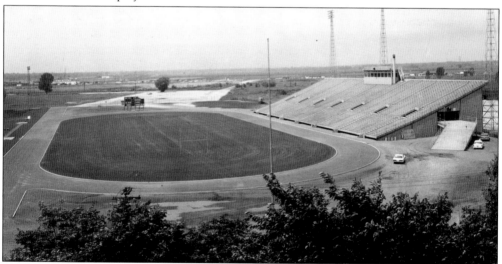

This photograph shows Gilroy Stadium in the early 1960s. The smaller, 8,000-seat facility was host to high school football games on Friday and Saturday nights, Catholic Youth Organization (CYO) games on Sundays, and a few small college games. St. Joseph's College, in Rensselaer, Indiana, played a few games there in the late 1960s and early 1970s. As the Gary high schools built their own stadiums in the 1970s, Gilroy's fate was sealed. The last game was played there on October 25, 1975, as Andrean routed Wirt 61-6. Today, Gilroy sits abandoned, a rusted structure waiting for the wrecking ball and a salvage outfit to take away the remains.

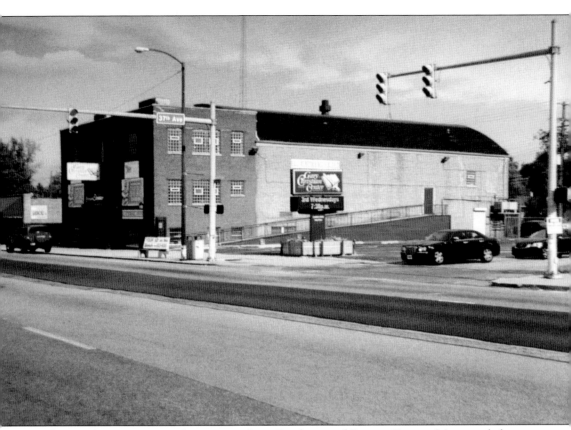

Gary became home to many ethnic groups from Southern and Eastern Europe. Many settled in the Steel City to find a new start with a job in the mills, while others escaped oppression from the Nazis or the Soviet Union. These new Americans not only built their own churches and schools, they also built fraternal societies and community centers to preserve their language, culture, and traditions. Pictured is the Croatian Center, at Thirty-seventh Avenue and Broadway. Today, the new complex is located in Merrillville, south of Route 30.

After the Gary Public Library built its main branch on West Fifth Avenue in the downtown section of the city, branches were built in every neighborhood. The Glen Park branch began operations in the 1920s. In the 1970s, the library, at 3975 Broadway, was modernized with the addition of a north wing that doubled the size of the local branch. In the photograph, the new wing is at left. (Author's collection.)

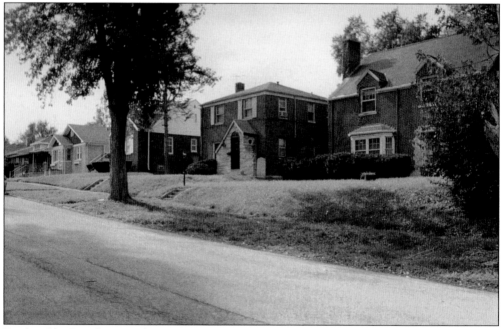

Bordered by Broadway on the east and Pierce Street on the west, the area from Gleason Park to Ridge Road was called Park Manor. Impressive homes of one and two levels were situated along beautiful tree-lined streets that followed the traditional grid pattern set by the Gary Land Company. Pictured are homes on the hill in the 3600 block of Madison Street. (Author's collection.)

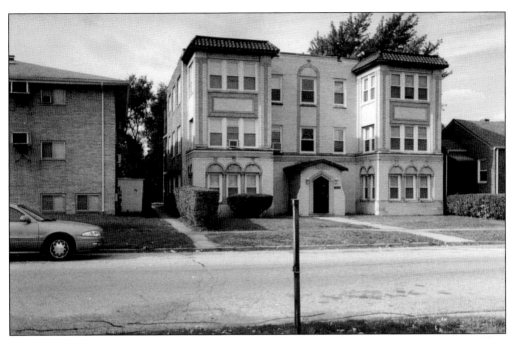

Park Manor had a number of impressive apartment buildings along Washington Street, as well as on Thirty-fifth Avenue, near the Indiana University Northwest campus and Gleason Golf Course. Pictured is an example of the classic style of apartments in the 3600 block of Washington Street, near Broadway. (Author's collection.)

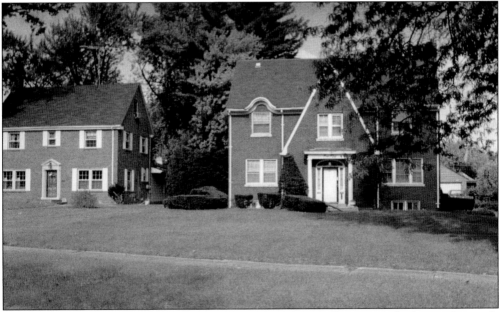

Gary had a number of exclusive neighborhoods where doctors, lawyers, and other professionals resided. Among them were Miller, along the lakeshore, parts of the Horace Mann community, and the Morningside section of Glen Park. Solid brick one- and two-story structures were built along tree-lined drives just south of Forty-fifth Avenue in Morningside. Pictured are homes on Forty-sixth Avenue just west of Broadway. (Author's collection.)

Many of the homes in this section of Glen Park were built from the 1920s through the 1940s. The lots were larger than the standard 40-foot-by-125-foot lots found in most areas of the Steel City, which followed the north-to-south grid pattern. Pictured are homes along the 4600 block of Jefferson Street, next to Lew Wallace High School. (Author's collection.)

In the late 1950s and early 1960s, the Junedale section of Glen Park was still in the process of building new homes on its remaining old farmland. A number of subdivisions were laid out from Forty-seventh Avenue south to Fifty-seventh Avenue in Merrillville. These were modern, brick ranch houses with full basements and attached garages. Pictured are homes along Fifty-third Avenue and Madison Street. (Author's collection.)

Two

BUSINESSES

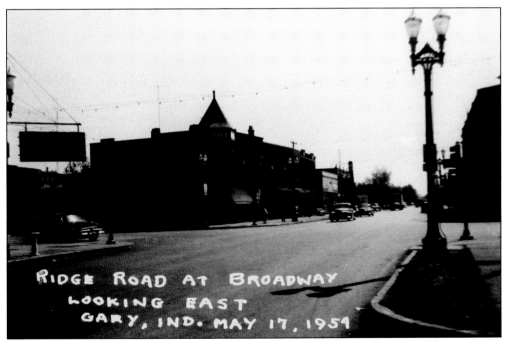

Another well-known landmark in Glen Park was the Zale Hotel and Tavern, on the northwest corner of Broadway and Ridge Road. For many years, the popular neighborhood tavern served the local clientele, who could walk in, have a beer, buy a meal, and see friends. Dickerson's Drugs is pictured at left in this 1956 photograph.

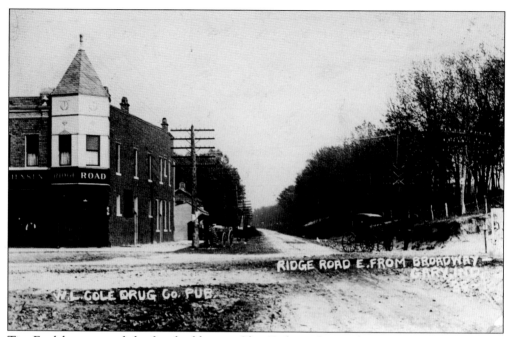

Tim Englehart erected the first building in Glen Park on the northeast corner of Ridge Road and Broadway. Ridge Road (Route 6), was a main east-to-west route that followed an old Indian trail in Lake County.

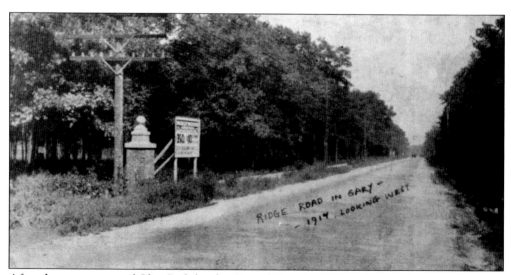

After the annexation of Glen Park by the City of Gary in 1909, real estate investors began to buy properties along Broadway and Ridge Road to set aside for business or residential properties. Pictured is a 1909 advertisement for land offerings along Ridge Road.

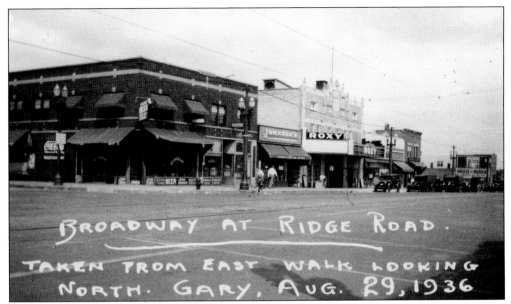

In 1936, much of the nation was still in the grips of the Great Depression. Steady jobs were difficult to find, and the employers who were hiring paid low wages with no benefits. Residents who were fortunate to have extra income often went to the movies or local theaters that offered live entertainment. Young couples who had the quarter needed for admission enjoyed the musicals and comedies produced by Hollywood, as it offered a chance to escape their problems for a few hours. For the cost of one ticket, one could watch a first-run film, a short movie, and a clip of Movietone News. Pictured is the Roxy Theater, at 3764 Broadway, next to Johnson's Drugs.

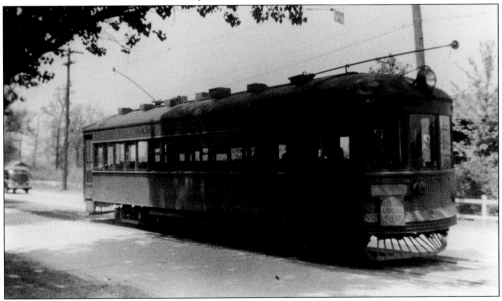

Years before the City of Gary took over the bus line, a private company owned the transportation system. It was first called the Gary Railway System, as trolleys and streetcars made up the network that lined the city and its surrounding communities. Until the 1960s, it was known as the Gary Transit Company. Pictured is a trolley at Forty-fifth Avenue and Grant Street. By the late 1930s, buses had replaced the old streetcars.

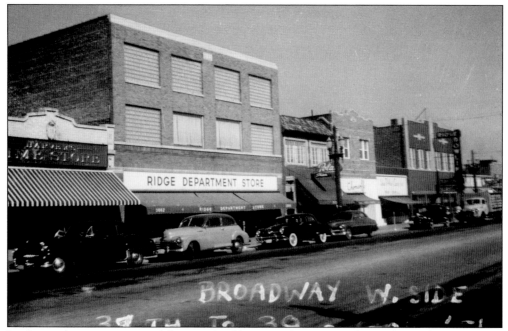

In the good economic times following World War II, downtown Glen Park merchants thrived. People had good jobs in the local mills and had money to spend. Clothing, appliances, furniture, and automobiles were American-made and of good quality. Local merchants knew their customers on a first-name basis, as well as their needs and spending habits. One of the major stores was the Ridge Department Store, at 3856 Broadway. It is pictured here in 1951.

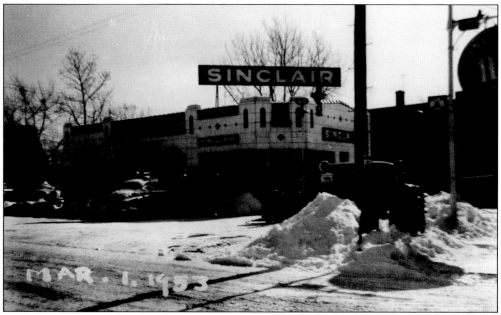

At the Sinclair station on the southeast corner of Forty-third Avenue and Broadway, patrons could get a fill-up and whatever service they needed. In 1953, customers could count on an attendant to pump the gas, check the fluid levels, and clean the windows. The mechanic on duty would provide needed maintenance. In addition, gas prices were less than 20¢ a gallon.

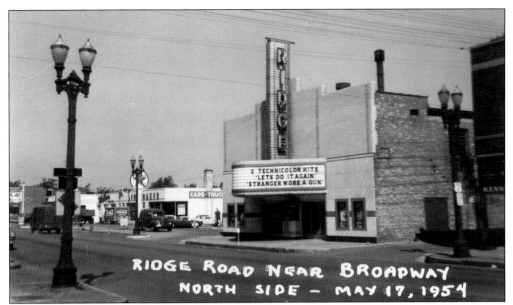

Just around the corner from the Roxy Theater and a half block west of Broadway was the former Ridge Theater. It catered to the local crowd, and, as fewer people relied on public transportation, the lack of available parking hurt attendance. It was later renamed the Glen and finally closed its doors in the 1990s. Today, a local group runs the theater and uses it on a limited basis.

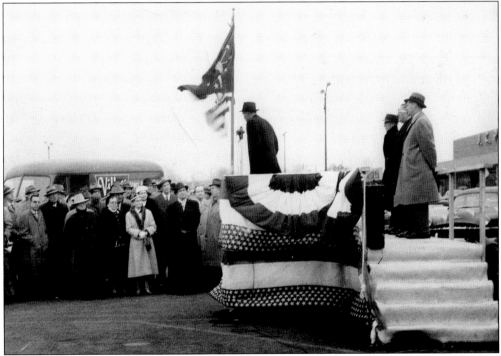

Gary's first shopping center, located at the intersection of Thirty-sixth Avenue and Grant Street, opened its doors in the 1950s. Though it was no comparison to the huge indoor malls that opened in the 1970s in the Midwest, it was a big draw and a boom for the local economy. Pictured are the crowds that gathered for the speeches at the ribbon-cutting ceremony.

One of the anchor stores of the Village Shopping Center was Montgomery Ward (seen here), the department store that sold items such as clothing, furniture, appliances, toys, and bath and kitchen goods. It also provided a full-service automotive department. In addition to "Ward's," the center was home to J.C. Penney, a local furniture store, a drugstore, a women's apparel shop, and a jewelry store. There were about two dozen businesses in the center, including a local post office and a branch of the Gary National Bank.

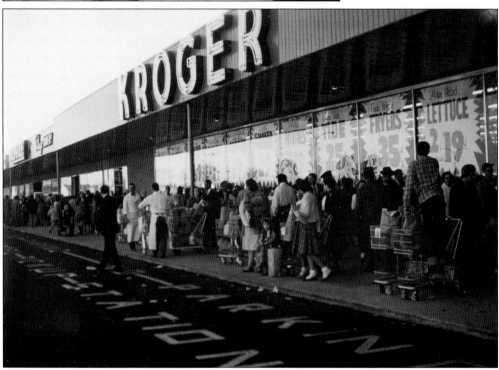

Kroger also opened its doors in the village during the grand opening to provide shoppers the opportunity to pick up their groceries as they concluded their shopping day. In addition to Kroger, Glen Park's other food stores included the A&P, in the 3400 block of Grant Street, Edmar Foods, on West Ridge Road, and Buy Low, on East Forty-ninth Avenue. Pictured are local shoppers waiting in line to pick up the bargains of the day. On closer inspection, the signs point out lettuce at two for 19¢, fryers for 35¢, and Tide for 25¢. Of course, it was 1955.

Like many local businesses, Montgomery Ward hired local high school students as part-time employees to earn extra money by working after school and on weekends. As a public relations move, the store chose young ladies to serve as its Wendy Ward representatives in cosmetics and clothing departments. Here, two young employees receive training from a supervisor.

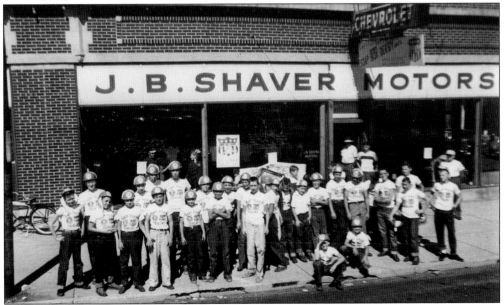

Glen Park claimed major automobile dealerships by the 1950s. Pictured is J.B. Shaver Motors, located at 3600 Broadway, which sold new and used Chevrolet cars and provided complete service for its customers. In addition, Bozak Motors, at 3568 Broadway, sold Chryslers, and McCanary Ford had a full-service dealership at 3300 Grant Street. All three left Glen Park for the suburbs in the 1980s. Here, young contestants pose for a group shot during the 1952 Glen Park Soapbox Derby, held each year. J.B. Shaver was a sponsor of the event, so the publicity never hurt.

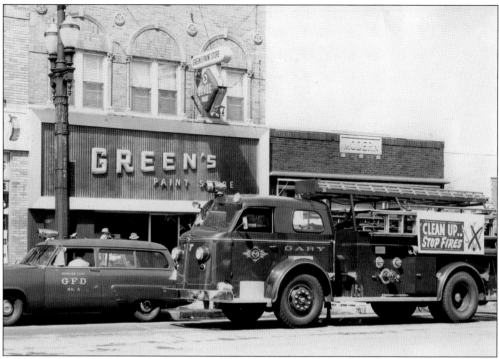

Long before Lowe's and Menards became the places to shop for everything under the sun in home improvement, local establishments such as Green's Paint Store served the Glen Park community. It is pictured here in the 1950s during Fire Prevention Week in Gary.

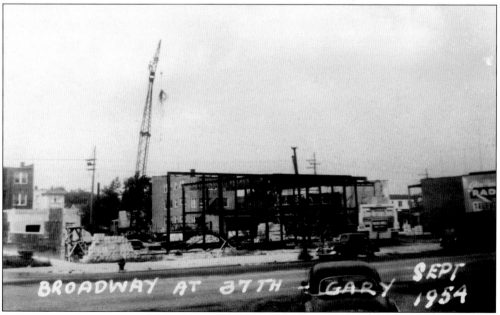

America's economy was booming in the 1950s. Business was good, and many were expanded their operations. In Gary, jobs were plentiful, especially at US Steel's Gary Works. In Glen Park, new housing went up and new stores opened. Pictured is construction on the new Gary National Bank branch at Thirty-seventh Avenue and Broadway.

On Saturday mornings or Sunday after church, large groups of local residents made it a point to stop at the Glen Park Bakery. Located in the downtown shopping area at 3708 Broadway, the bakery sold a variety of fresh breads, cakes and pies, and a vast assortment of tasty pastries. Former residents who moved south to the suburbs in the 1970s still took the drive back to the old neighborhood to bring home fresh goods from the popular business. By the 1990s, the old place finally closed its doors. Today, it sits boarded up and abandoned.

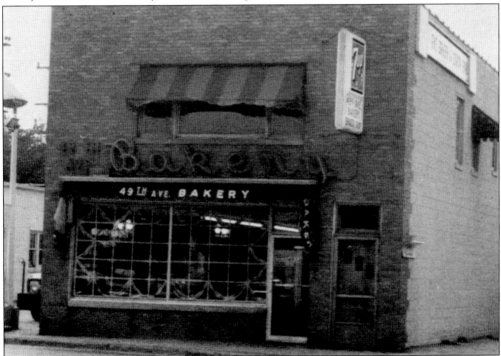

A popular family-owned business in the Junedale section of the Glen Park neighborhood was the Forty-ninth Avenue Bakery. Pictured here during better times in the 1970s, it was the place to shop for locals on weekends for fresh bread, pies, and a large selection of ethnic pastries. Now closed, it sat across from the old Ace Hardware on Broadway and Milan's on Forty-ninth Avenue.

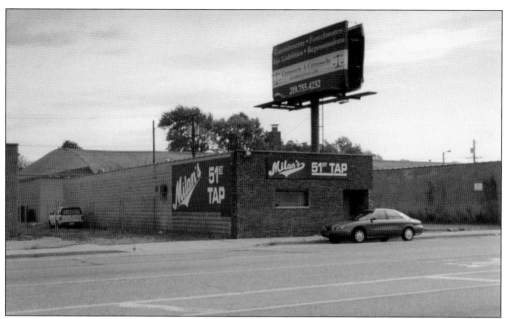

Milan's was established by Milan and Katy Jelovcic and has served its clientele from its South Glen Park location since the early 1970s. Milan was a real American success story. He escaped Communist oppression in Eastern Europe, gained asylum in the United States, and became a citizen. Starting with very little, he worked hard and saved enough to begin his own business. After his passing, his family continued the business. (Author's collection.)

Variety, located in the 4400 block of Broadway, was a popular neighborhood bar where one could walk in, have a beer and a sandwich, and share a good time with friends. The business, now closed, was across the street from the Flamingo Lounge. (Author's collection.)

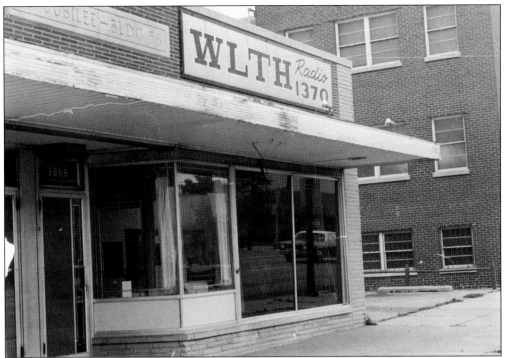

One of Gary's two radio stations did its daily broadcasts from its studio in the 3600 block of Broadway. Originally, the station's call letters were WGRY, and the format was rock and roll music with hourly newscasts. The station changed to all talk in the early 1970s as WLTH. Warren Freiberg, popular as well as controversial, became the daily talk show host. He was the Rush Limbaugh of his day.

Tittle Brothers Meatpacking began operations in the 600 block of Broadway, in the city's downtown. Later, the popular meat store expanded to Glen Park and Miller. In the 1980s, the business closed for good. The former store, located near the Village Shopping Center, is now occupied by the Indiana University Drama Department. (Author's collection.)

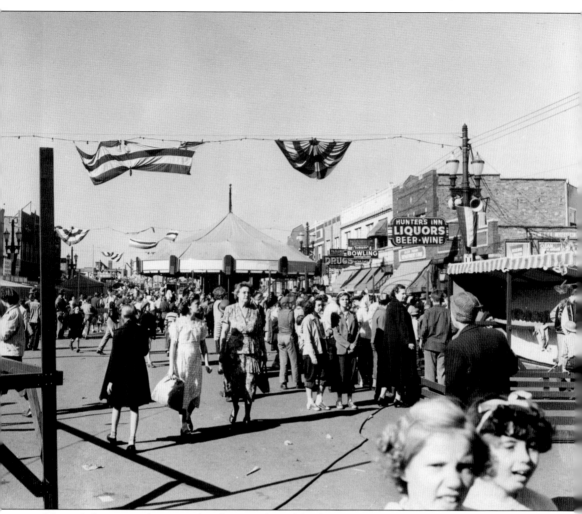

Hunter's Inn was a longtime family-owned neighborhood bar that served north Glen Park for over 60 years and was located in the 3800 block of Broadway. It is pictured here in 1949 during the Glen Park Jubilee celebration.

Three

CHURCHES

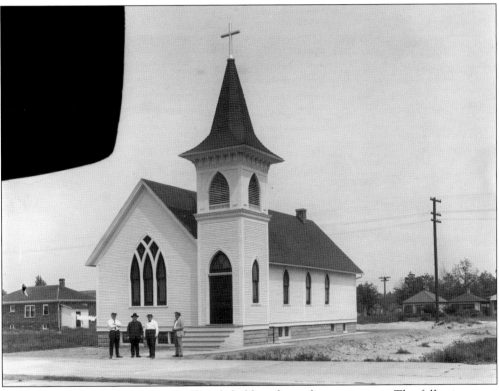

In 1910, the Glen Park Christian Church held its first religious service. The following year, through the hard work and long hours of the congregation, the church was dedicated. Later, other churches were established to meet the spiritual needs of the growing community. Roman Catholic, Orthodox, and Protestant places of worship were established. Like the Glen Park Christian Church, their members not only raised the needed funds, but also built the churches themselves. Pictured here around 1910 is one of the early churches, Emmanuel Lutheran Church, at 3956 Washington Street.

Polish families from Gary's Central District began to relocate to Glen Park in the early 1920s. Many were from the Polish Parish of St. Hedwig. By 1923, a decision was made to purchase 3.5 acres of land at Thirty-seventh Avenue and Delaware Street and build a church and school. It was to be within walking distance of most of the congregation. Finally, on August 8, 1926, Bishop John Francis Noll of the Diocese of Fort Wayne blessed and dedicated the church. Pictured is the original wooden structure in the early 1930s. (Courtesy of Cheryl Andricks.)

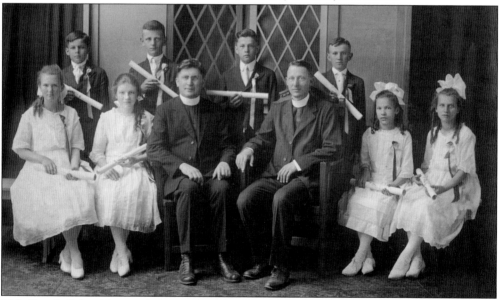

Holy Family School began classes in the fall of 1926. Out of some 250 eligible students, only 90 could be accommodated in the parish school, which was located in the church basement. Many of the students had originally attended St. Hedwig School, which was some distance from Glen Park. With a new Polish Catholic school in the neighborhood, their parents transferred them to Holy Family. The school's first graduation of eighth-graders was in the late 1920s. Seated in the left center is the parish pastor, Fr. Michael Gadacz. (Courtesy of Cheryl Andricks.)

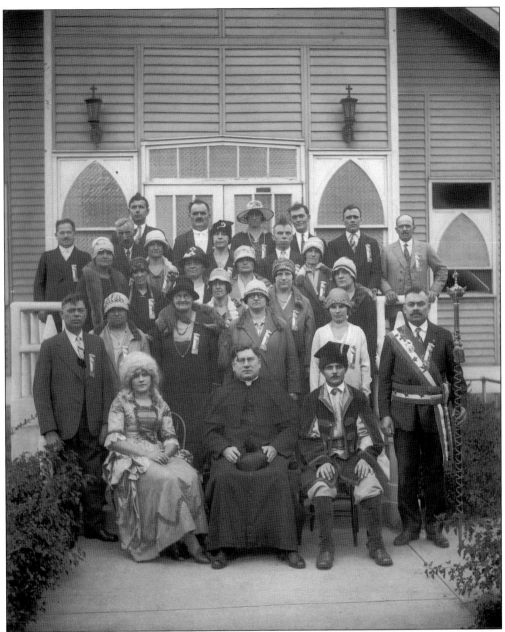

Holy Family parishioners established a number of lodges and parish organizations in the 1920s to foster a sense of family and community for its members. The Holy Name Society, the Parish Council, and the Ladies Sodality were just a few. Pictured is a Polish lodge that helped first-generation Poles pass on the culture and traditions of the Old World to the next generation. Lodges also raised money for the parish and sold insurance to the members. (Courtesy of Cheryl Andricks.)

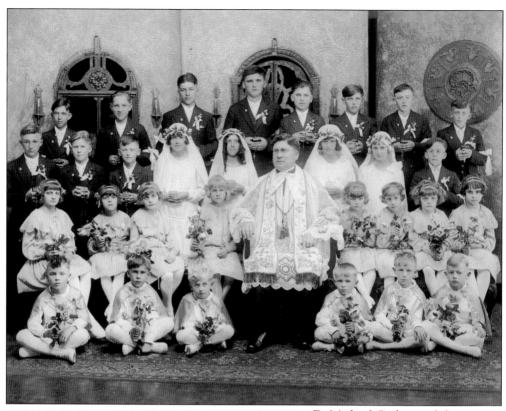

Fr. Michael Godacz and the children of Holy Family School are pictured at a First Communion class in the early 1920s. As the school increased its enrollment, the classes often reached 50 to 60 students receiving the sacraments. A few classes were nearly as big as 100 in the late 1920s, as Catholic children from the public schools in the neighborhood were allowed to participate if they took instructions after school at Holy Family. (Courtesy of Cheryl Andricks.)

Another parish organization at Holy Family Church was the Holy Family Society. The parish group is pictured here outside the original church in the late 1920s. (Courtesy of Cheryl Andricks.)

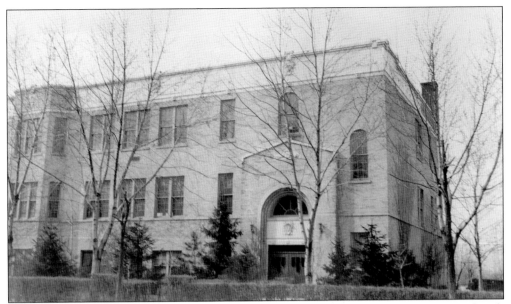

As school enrollment continued to increase, a decision was made to raise funds for a new church and school building. In 1929, the cornerstone for the new structure was blessed and dedicated. The school building is pictured in 1939. (Courtesy of Cheryl Andricks.)

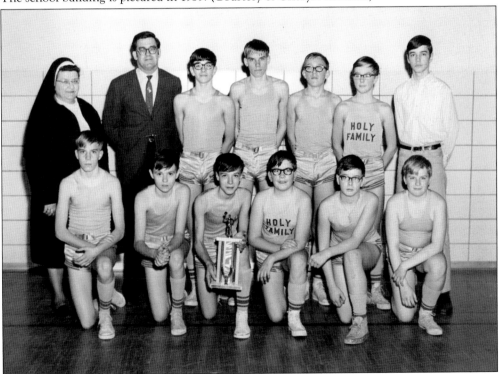

Gary's Catholic Youth Organization (CYO) ran an organized sports program for the elementary students in the parochial schools of the diocese. Catholic schools competed in team sports such as football, track, and basketball. Later, girls' sports programs were added. This Holy Family School basketball team was CYO champion in the early 1960s.

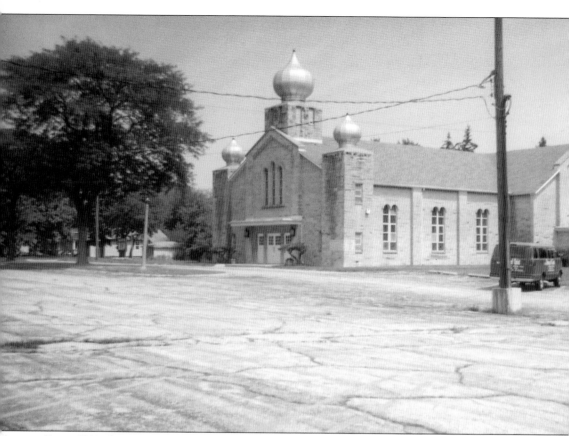

Since 1911, the Protection of the Virgin Mary Orthodox Church served the Russian Orthodox faithful in Gary. The original church was dedicated and carried its mission at 1600 Fillmore Street in the city's Central District, with the Rev. Benjamin Kedrovsky as pastor. The church members decided to build a new church at 505 East Forty-fifth Avenue to meet the needs of the growing membership. In January 1962, St. Mary's was consecrated and dedicated by his Eminence Archbishop John. It is pictured here in a recent photograph. (Author's collection.)

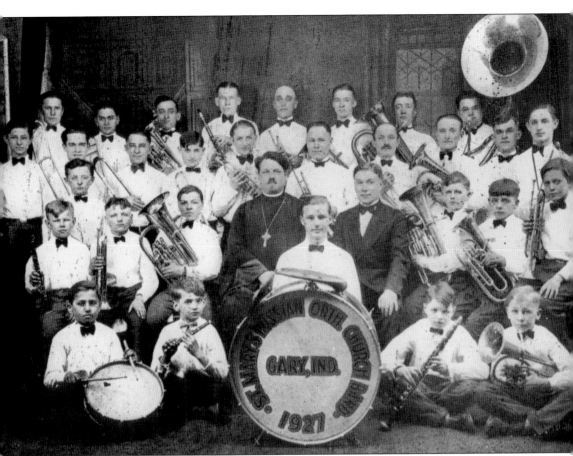

All early ethnic churches in the region established social organizations and lodges to help members form a sense of pride and community. These groups helped preserve languages, religions, and traditions of the Old World and pass them on to the next generation. With few modern distractions, such as television, radio, or the Internet, membership grew in these church-led social organizations. Here is a 1927 photograph of the St. Mary's Orthodox Church band with the pastor and director.

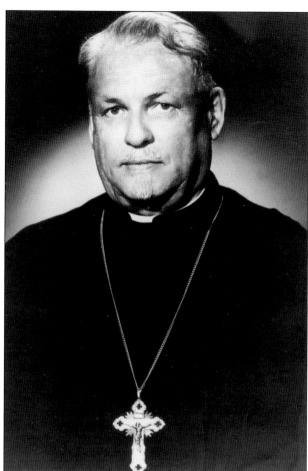

In 1911, the Rev. Benjamin Kedrovsky was appointed the first permanent pastor of St. Mary's Orthodox Church. He would continue to serve his pastoral duties until 1957. He passed away in November 1968.

In 1986, St. Mary's Orthodox Church celebrated its 75th anniversary in Gary. Past and present members of the church joined in to give thanks and share their memories of the church. Pictured is the St. Mary's choir at the anniversary gathering.

The anniversary celebration for St. Mary's drew parish members from every generation. Berthal Kowal, a parish member since the church was in Gary's Central District, is pictured here with the rector, the Very Rev. Fr. Peter Rozdelsky.

In the spring of 1929, the first services were held at the Forty-third Avenue Presbyterian Church, which was located on the northwest corner of Forty-third Avenue and Washington Street. The first pastor was the Rev. Harold R. Marten, who was installed in 1926. The church served the Presbyterian congregation in Glen Park for over 50 years; however, with declining numbers and families moving to the suburbs, the last service was held on November 9, 1989. Today, the remaining congregation is part of the Christ Presbyterian Church of Crown Point. (Author's collection.)

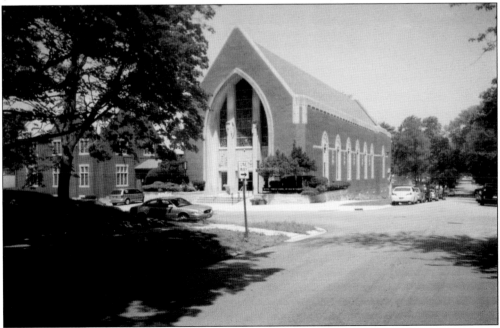

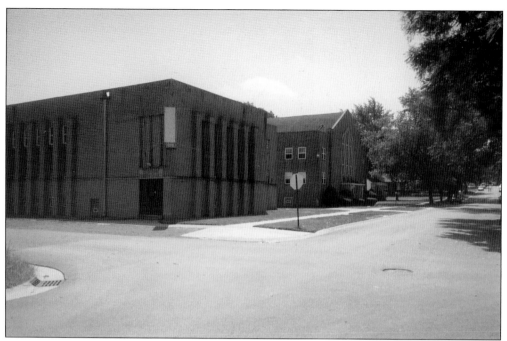

Glen Park Baptist Church, located in the 4200 block of Washington Street, was built and dedicated in the 1930s. The church served the growing congregation for over 50 years. Sadly, the church closed some years ago as the population began to move south to the suburbs. (Author's collection.)

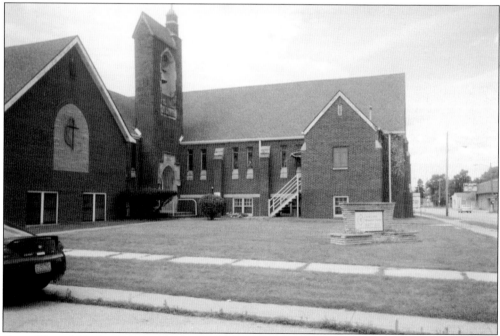

Grace United Methodist Church served the spiritual needs of its congregation for over 50 years. The church, located at Ridge Road and Adams Street, also served the local Glen Park community by offering various social and charitable aid. (Author's collection.)

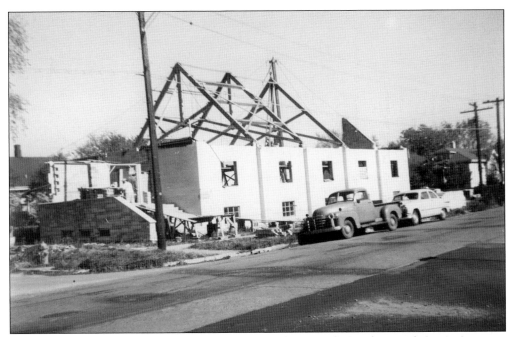

Plans were completed in the early 1950s to build a church for the Steel City's Assyrian community. The decision was made to purchase the property at the northwest corner of Thirty-fifth Avenue and Delaware Street on Glen Park's East Side. The church is pictured here undergoing construction.

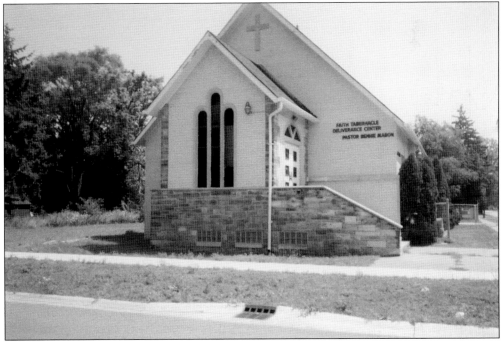

The Assyrian congregation was eventually forced to seek a new location as membership declined and younger families continued to move out of Gary to the suburbs. Pictured is the old church building in the early 2000s. (Author's collection.)

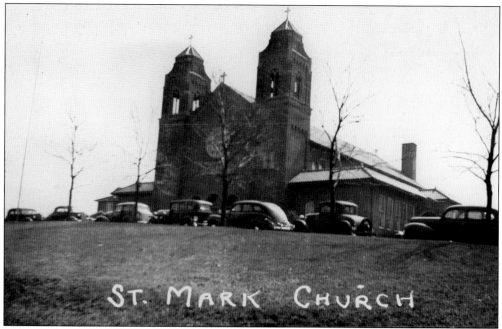

ST. MARK CHURCH

The Parish of St. Mark's Roman Catholic Church began in 1921 at Thirty-ninth Avenue and Broadway. Six years later, when Fr. Joseph S. Ryder was pastor, a new church and school were dedicated at 501 West Ridge Road. It is pictured here on the hill looking south from Ridge Road in 1940.

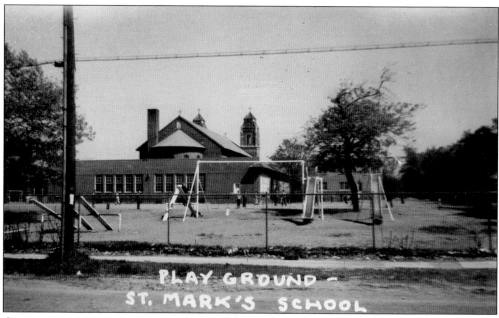

PLAY GROUND - ST. MARK'S SCHOOL

At one time, recess was an important part of the elementary school day. Children would take part in dodgeball, red rover, and kick ball, or just go on the swings and slides. Sadly, most elementary schools in the area have since ended such features. Pictured here is the St. Mark's playground in the good old days of 1954.

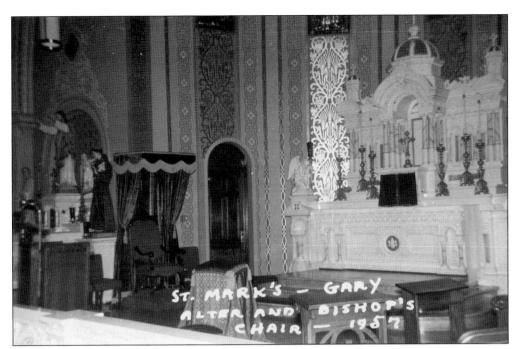

In this 1950s photograph, the main altar of St. Mark's Church is shown, with the bishop's chair at left. The parish was probably getting ready for a visit from the bishop for a special celebration, such as confirmation.

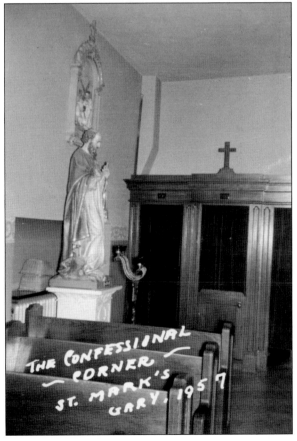

On Saturday afternoons, St. Mark's Church was open so that parishioners could receive the Sacrament of Penance, and during the Christmas and Easter seasons, the parish would bring in extra priests to assist. The turnout of those who wanted to receive the sacrament was far greater at those times of the church calendar. Pictured are the confessionals, at the rear of the church.

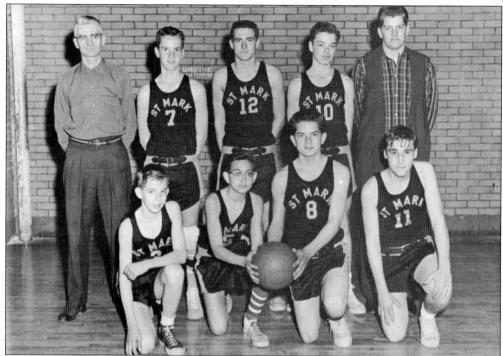

The Diocese of Gary and the CYO sponsored a sports program that included football, basketball, and track. Catholic schools throughout the area competed in these supervised sports to win league championships. The St. Mark's boys' basketball team is pictured in the mid-1950s.

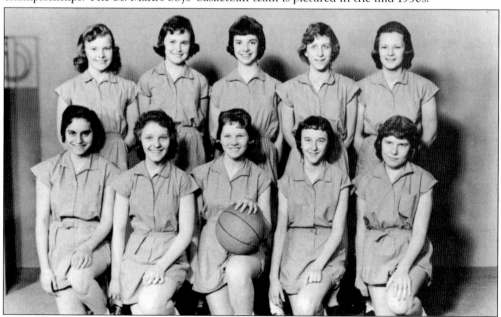

With the addition of organized girls' sports by the Diocese of Gary, the CYO opened athletic competition to more elementary students. Schools allowed young ladies to compete in seventh- and eighth-grade track and basketball programs run by parish volunteers. Pictured is the St. Mark's girls' basketball team of 1958.

In September 1996, the parishioners of St. Mark's observed the 75th anniversary of the parish. Bishop Dale Melczek celebrated the jubilee mass at the church, and, afterward, a banquet was held at the Hellenic Cultural Center. Parishioners and former members gathered to renew old friendships and share fond memories. Pictured is the pastor, the Rev. Robert Gehring.

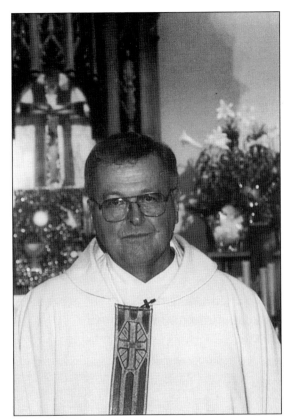

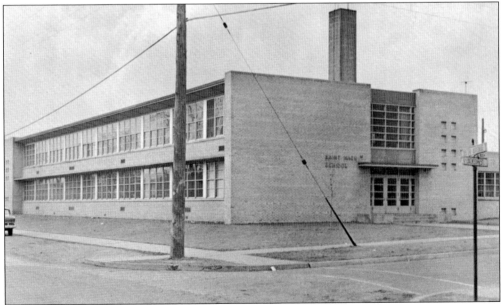

Enrollment at St. Mark's School continued to increase, in part due to the postwar baby boom. In April 1951, a new building was completed at Thirty-ninth Avenue and Jackson Street at a cost of $300,000. That same year, an addition to the convent was constructed. The east entrance to the school is pictured in 1951.

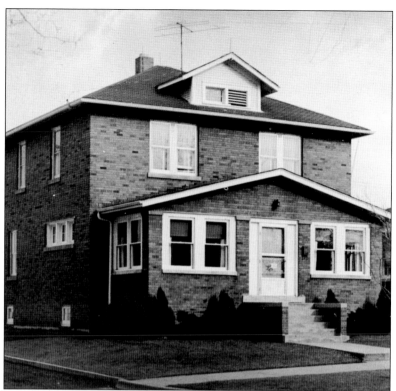

In 1927, after St. Mark's Church moved to its present location at 501 West Ridge Road, a church was built and classrooms were added along the east and west sides of the structure. The first rectory was located across the street from the church, at 3839 Monroe Street. The former rectory is pictured here in a recent photograph.

For many years, the Sisters of the Poor Handmaids of Jesus Christ served the parish of St. Mark and the schoolchildren that they taught. By the early 1970s, lay teachers began to replace the sisters at the school, which was not only taking place throughout the diocese but also the country. Pictured is the rectory that once housed the sisters of the parish. (Author's collection.)

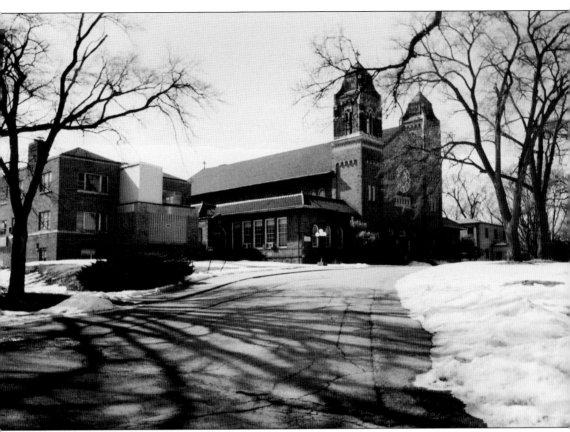

The new rectory was completed in December 1949 just east of the present church. The Rev. Francis A. De Guerre was the first pastor to take residence there. In 1956, he left because of poor health. The bishop appointed Fr. Fred J. Westendorf, a decorated Army chaplain who had served in World War II, as the new pastor of the parish. The rectory is pictured here to the left of the church. (Author's collection.)

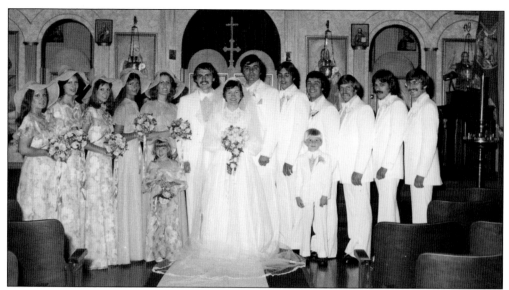

St. Elijah Serbian Orthodox Church served its congregation in northwest Indiana from its location at Forty-first Avenue and Adams Street until the late 1970s. Pictured is the wedding of Mike and Myra Lalic in June 1976. Rev. George Lazich, the pastor, conducted the wedding ceremony. (Author's collection.)

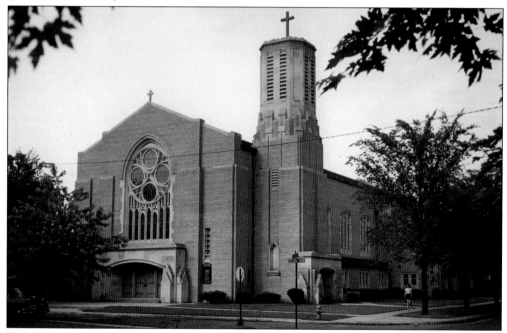

Holy Trinity Church, founded in 1912, served the Croatian Catholics of Gary for over 30 years from its Central District parish at Twenty-third Avenue and Adams Street. In 1943, a new church and school were built in Glen Park at Forty-third Avenue and Delaware Street. With the continued growth, a decision was made to build a new, larger church to serve the faithful. Construction began in 1954, and Bishop Leo A. Pursley dedicated the church on May 6, 1956. The new church was blessed and given the title St. Joseph the Worker. Pictured is St. Joseph the Worker Church around 1960. Today, Fr. Stephen Loncar serves as pastor.

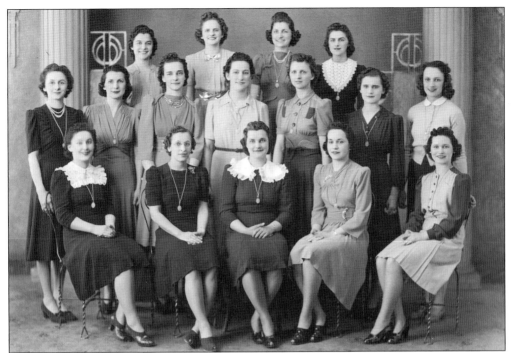

St. Joseph the Worker Church had a number of organizations to assist in the various duties of the parish. Among the groups were the Rosary Sodality, the Holy Name Society, the Home and School Council, and, the oldest, the Altar Society. Pictured is the Ladies Sodality in the early 1940s. (Courtesy of Fr. Stephen Loncar, OFM Conv.)

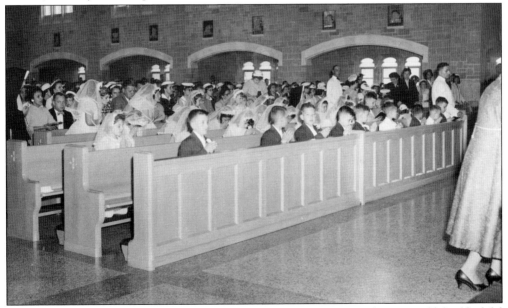

Receiving the Sacrament of the Holy Eucharist is an important part in the spiritual life of faithful Roman Catholics. First Communion is always special for the children and their families. Pictured are the children of St. Joseph's First Communion class in 1957. At the time, the stained-glass windows were not yet installed. (Courtesy of Fr. Stephen Loncar, OFM Conv.)

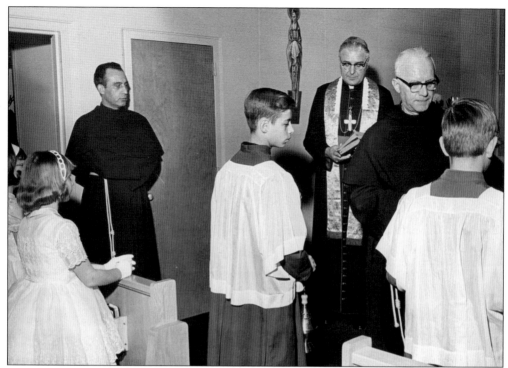

Pope Pius XII appointed the Most Rev. Andrew G. Grutka as the first bishop of the Diocese of Gary in the late 1950s. Until Bishop Grutka's elevation, all Roman Catholic parishes were under the Diocese of Fort Wayne. Bishop Grutka is shown here presiding over a dedication ceremony at St. Joseph the Worker Church in 1966. At left is Fr. Benedict Benadovic, OFM, and Fr. Mirko Godina, OFM, is seen at right.

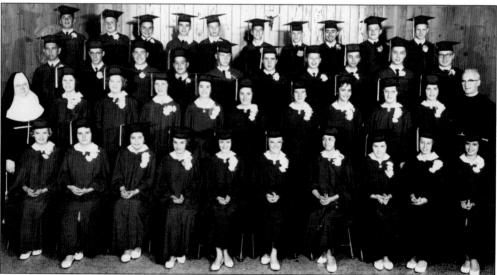

In the 1950s and 1960s, student populations in the Diocese of Gary schools began to decline in parts of the Steel City, but it was steady or growing in other areas, such as Glen Park. Pictured is the 1961 eighth-grade graduating class of St. Joseph the Worker School. (Courtesy of Fr. Stephen Loncar, OFM Conv.)

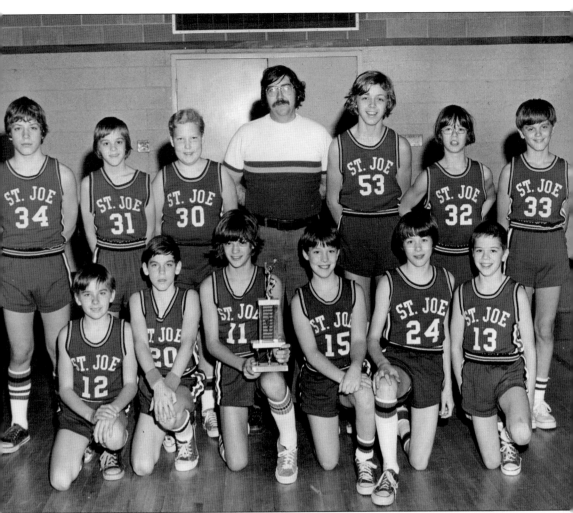

CYO boys' and girls' sports were popular at St. Joseph the Worker School, and a number of teams earned success through hard work and working as a team. In 1974, the school's basketball team was runner-up in the tournament. Pictured are players and coach Robert McConnell. (Courtesy of Fr. Stephen Loncar, OFM Conv.)

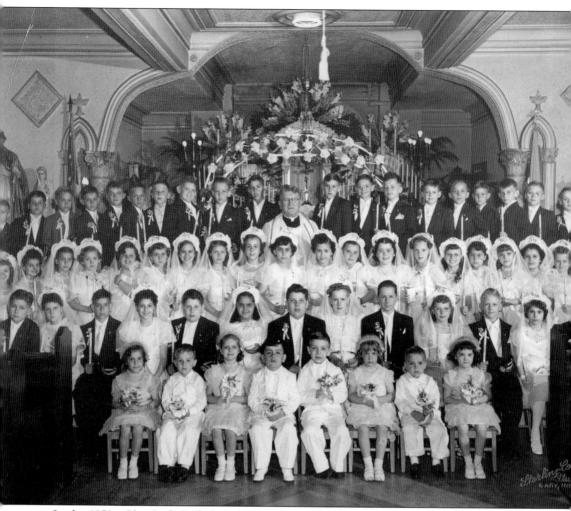

In the 1950s, Glen Park Catholic schools continued to increase their student enrollments. First Communion classes often reflected that growth. Pictured is the Holy Family First Communion class in the mid-1950s. (Courtesy of Cheryl Andricks.)

Four

EVENTS

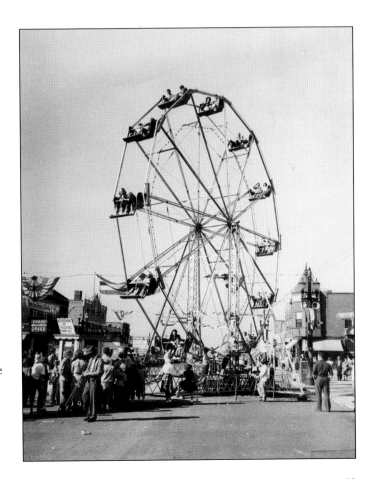

In 1949, the City of Gary went all-out to celebrate the golden jubilee of the Glen Park community. The intersection of Ridge Road and Broadway, downtown, became the midway of the carnival. Pictured is the Ferris wheel, on the north side of the intersection.

By the 1920s, Gleason Golf Course began to hold local tournaments that allowed the best local talent to compete by age brackets. Pictured in this 1925 photograph are school-age contestants. The young man in the second row, fifth from the right, would one day be Gary's chief executive, Mayor George Chacharis.

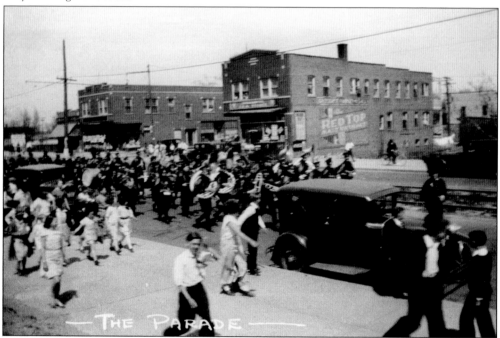

Everyone loves a parade. In 1934, the American Legion hosted its event in Glen Park along Broadway. The parade participants included local school bands, floats, decorated vehicles, and dignitaries. The second building from left was later known as the Three Poles Tap, run by Raymond Lis, Chester Piatuk, and Chester Checielski, three Polish guys.

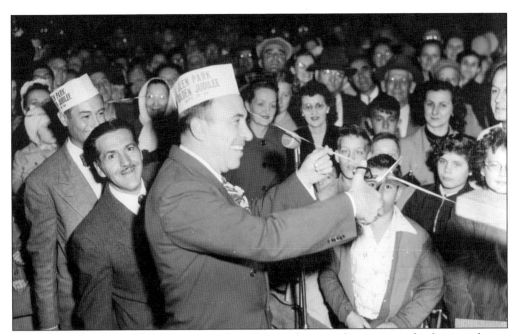

The Glen Park Golden Jubilee drew a number of city and county dignitaries and politicians during its festivities. Here, Mayor Eugene Swartz cuts the ribbon to officially open the event. Mayor Swartz was the last Republican to hold the office of Gary's chief executive.

Visitors wait in line for the next seat on the Ferris wheel at Ridge Road and Broadway in the evening. Visible is the Zale Hotel and Tavern. It is likely that a few adults stopped in the bar to get a stiff drink to build up their courage before getting on the wheel.

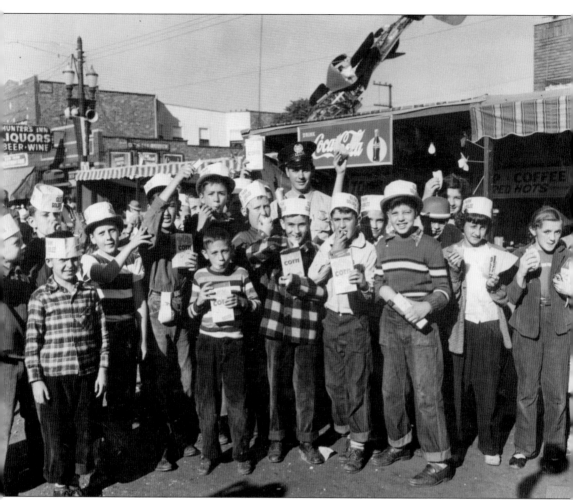

If there was one thing parents were sure of, it was that their youngsters would load up on plenty of food and soda at the carnival. Here, local kids enjoy plenty of popcorn, pop, hot dogs, and other types of food. Local vendors were very pleased to satisfy their appetites. Parents probably were not.

Broadway was completely closed during the jubilee in 1949. In addition to the rides, local vendors set up booths to sell their goods, while the carnival set up games and contests that offered prizes if contestants won.

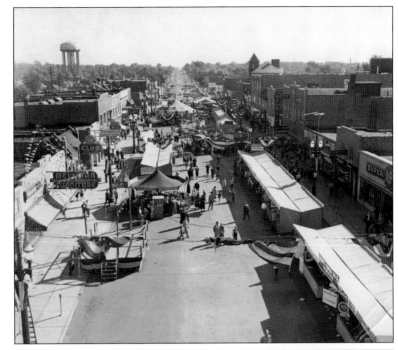

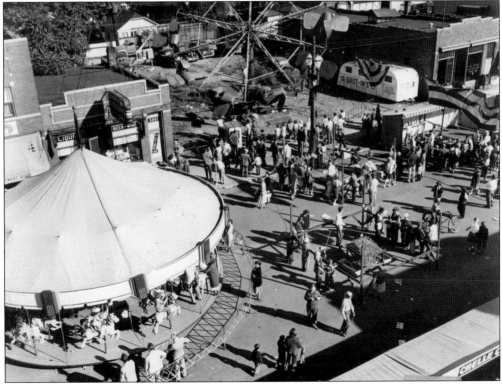

Farther south, along the Broadway midway and in vacant lots, additional rides provided enjoyment for visitors. In this afternoon shot, a merry-go-round and a sky-ride are visible. Local stores and taverns took in additional business from the festive crowds.

One of the more challenging rides of the jubilee festival was the Tilt-a-Whirl. Riders were seated and spun around a circular moving floor at a pretty good clip. After plenty of food and soda, if not anything stronger, many riders felt more than just motion sickness.

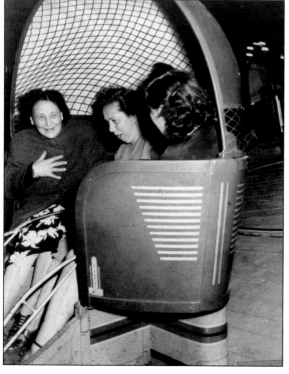

Apparently, these local ladies were pretty glad the ride was finally over. Of course, they may have taken on another ride later.

If one just wanted a break from the rides, they could relax for a while and listen to the music provided by local bands and singers. Here, the Lew Wallace Band performs a number in front of the old A&P store on the east side of the midway on Broadway.

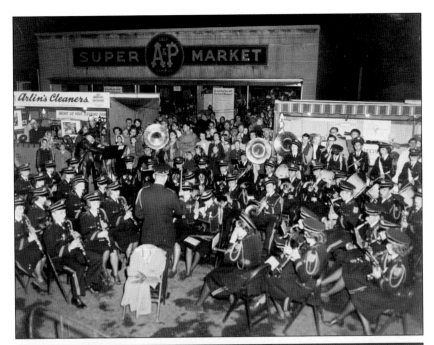

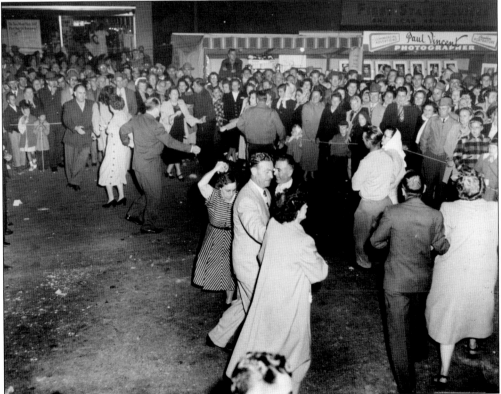

As bands performed their numbers, many in the crowd found time to dance to the music with their wives or sweethearts. A number of ethnic favorites were played, to the satisfaction of all age groups. Rock and roll was still a few years away.

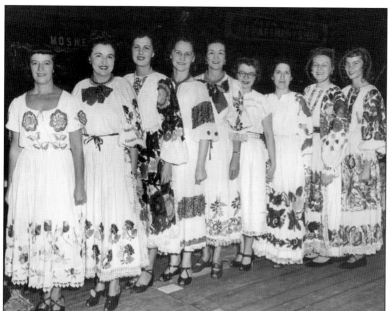

With many ethnic groups taking part in the jubilee, many ladies dressed in costumes that presented pride in their ancestry. Here, ladies are attired in various Eastern European dresses.

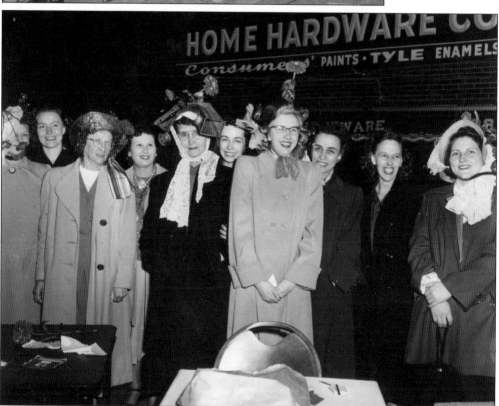

In 1949, WGN-TV began televising Chicago Cubs baseball. Arnie Harris, the producer, had the cameramen scan the field to find the hat of the day, usually a wild type of head attire. Maybe old Arnie was present at the Glen Park Golden Jubilee and got the idea from this group of ladies who posed for this classic photograph.

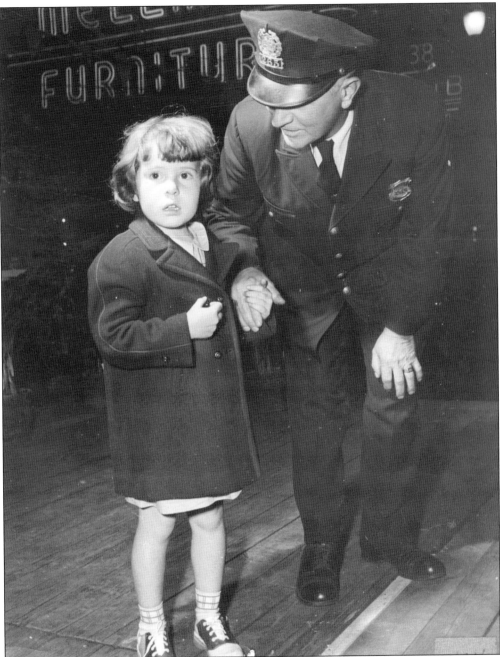

Whether at a county fair, carnival, or festival, someone always gets separated from his or her group. In this case, a little girl seems to be lost at the jubilee. Fortunately, one of Gary's finest was there to help reunite her with her family.

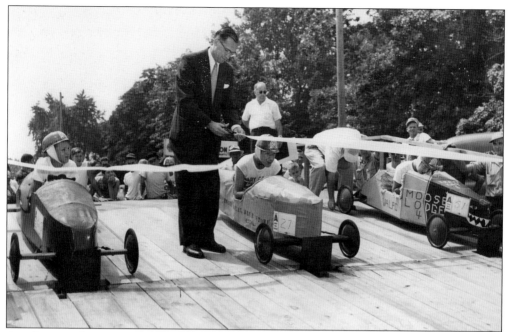

Another popular community event was the annual soapbox derby, which ran from the hill on Forty-third Avenue and Broadway north to about Forty-first Avenue. The young contestants designed and built their own racing vehicles according to set specifications, which included maximum weight. Here, Mayor Peter Mandich gets contestants ready to start the race.

Contestants in the soapbox derby began the race at the Forty-third Avenue starting point, located at the top of the ridge. They continued north on Broadway to Forty-first Avenue. This was the view from the starting point going north.

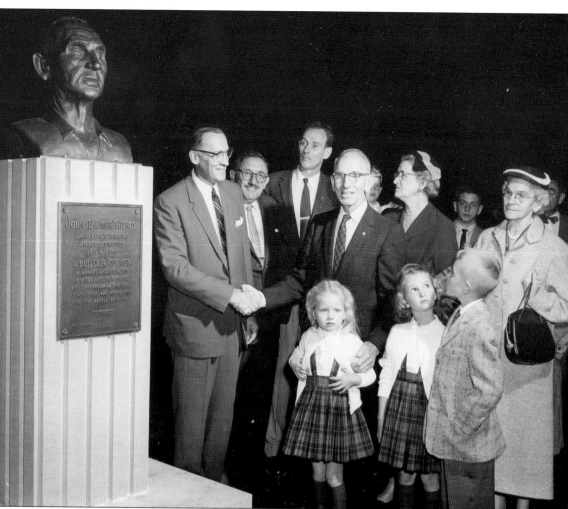

After Gilroy Stadium was completed, the city held a dedication ceremony for Jack Gilroy. Pictured with the Gilroys are Mayor Pete Mandich and George Chacharis. The dedication took place in 1956.

After the resignation of George Chacharis in 1962, John Visclosky was appointed interim mayor of Gary. He did not run for reelection in 1963. Instead, Judge A. Martin Katz was nominated in the primaries and won the general election that year. Visclosky's son Pete later became the US congressman for Indiana's 1st congressional district.

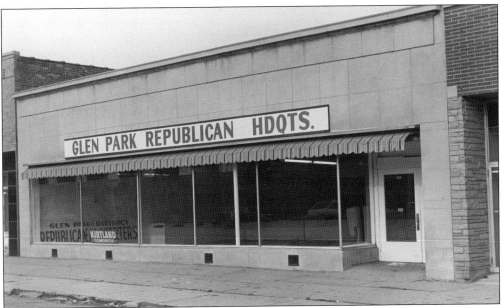

Political campaigns and elections were always major events in the Steel City. Lake County became a major Democratic stronghold after Pres. Franklin Roosevelt's landslide victory in 1932. However, there were a number of Republican pockets of strength in the region. Glen Park had a number of candidates who were successful. Pictured is the Glen Park Republican Headquarters in 1970.

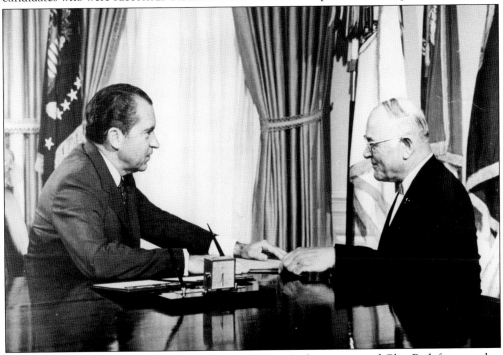

One popular GOP city councilman was Eugene Kirtland, who represented Glen Park for a number of years. Kirtland was not only an outspoken critic of the administration of Mayor Richard Gordon Hatcher, he was also a staunch defender of the Glen Park community. He is pictured here with Pres. Richard Nixon in 1970.

Junedale LITTLE LEAGUE BASEBALL

SANCTIONED BY LITTLE LEAGUE BASEBALL, INC., WILLIAMSPORT, PENN.

OFFICAL SCORE CARD
1953 SEASON

THE JUNEDALE LITTLE LEAGUERS OATH: *"On my Honor, I will try to do my duty to God and my Country and to obey my Parents at all times"*

LITTLE LEAGUE DEPENDS ON THE SUPPORT OF THE PUBLIC FOR ITS CONTINUED OPERATION. YOUR MONETARY AND PHYSICAL ASSISTANCE WILL BE HIGHLY APPRECIATED—MEMBERSHIP CARDS SOLD AT REFRESHMENT STAND

SWENEY ELEC. COMPANY, INC.
"SPARKS"

MANAGER	– JOHN GARAPICH
COACHES	– BOB MAGNETTI
	JOE DEAL
	HERB LUCK
	WILLIAM WARCHUS

JIMMIES DAIRY
"HALF PINTS"

MANAGER	– GEORGE STUPAR
COACHES	– JOHN MAHONEY
	CLYDE MCKINNEY
	LONNIE JACKSON

F. O. P. #61
"LITTLE TOOTS"

MANAGER	– AL TERZES
COACHES	– NIBS CORBEILLE
	EARL CLEMENT
	WILLIAM MANN

F.O.P.A. #2
"LITTLE PALS"

MANAGER	– RAY HOCKLEBERG
COACHES	– JIM TARPO
	JIM MAYBAUM
	STAN. FRANKOWSKI
	MIKE DEMBOWSKI
	PAUL MACKANOS

MINOR LEAGUE SPONSORS

BARLOCK SERVICE JOHN ERDELAC'S CITIES SERVICE

ROBERTS SERVICE MICHAEL'S SERVICE

— ⊗ — ⊗ — ⊗ —

SCOREKEEPERS:	CHIEF UMPIRES:	UMPIRES:	
DALE ROTH	EMIL PEDERSEN	GARRETT FAGAN	JIM MCNIECE
CHARLES POWELL	STEVE BARLOW	KENNETH SIECKMAN	DON DILLMAN
		DAVID BONE	WES FARRELL
		HANK VORWALD	JOHN WARIEKA

NOTE OF THANKS: *The Managing Personnel of Junedale Little League wishes to thank all those who have so unselfishly contributed their time and labor or their financial support to insure the continued operation of the League.*

Though the Senior Series would not be held in Gary until 1968, a trial proposal was already being put together. In 1952, Junedale hosted the District I Tournament. Local politicians, dignitaries, and WWCA Radio took part in the event. Pictured is the cover of the 1953 program.

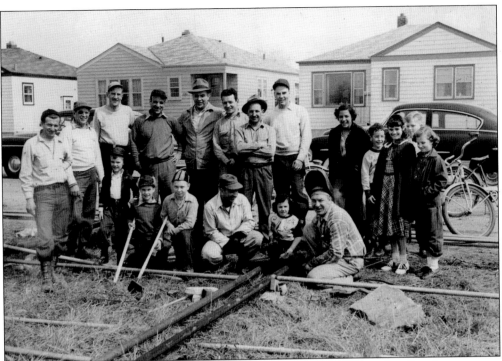

It took a citywide cooperative effort to make the first tournament a reality. Local contractors provided needed materials to build the first field that would host the tournament. Local volunteers gave many hours of their time to get the field ready in 1952.

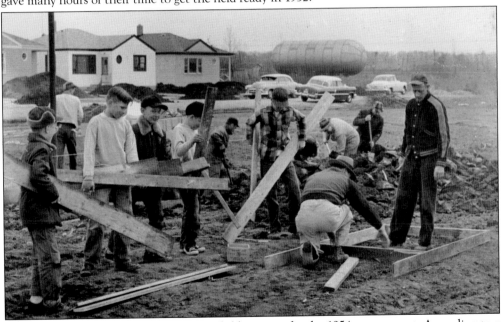

With the popularity of the games, a new field went up for the 1954 tournament. According to a source, a near accident was the cause. An outfielder was trying to catch a long fly ball and ran toward the street, and a car nearly hit him. Here, the construction crews put up new outfield stands in 1954.

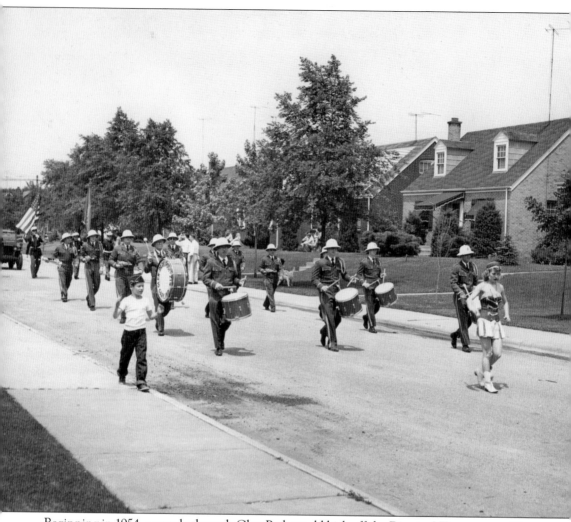

Beginning in 1954, a parade through Glen Park would kick off the District I Tournament. Here, a local high school band marches along West Forty-ninth Avenue, a few blocks away from the ballpark, in 1954.

This aerial shot of Junedale Field shows the field looking east toward Madison Street in the early 1950s. Over the coming years, new stands and parking were added for the fans.

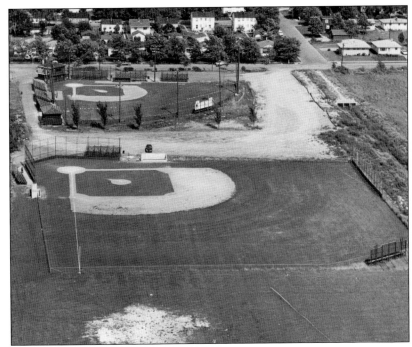

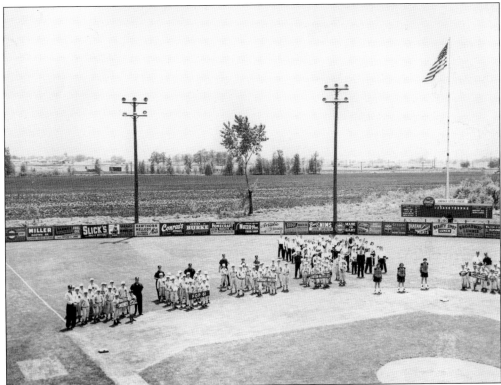

In another aerial shot, the teams are shown during the opening ceremonies in the early 1950s. The photograph shows the field looking south. In less than 10 years, the area to the south would be filled with new subdivisions.

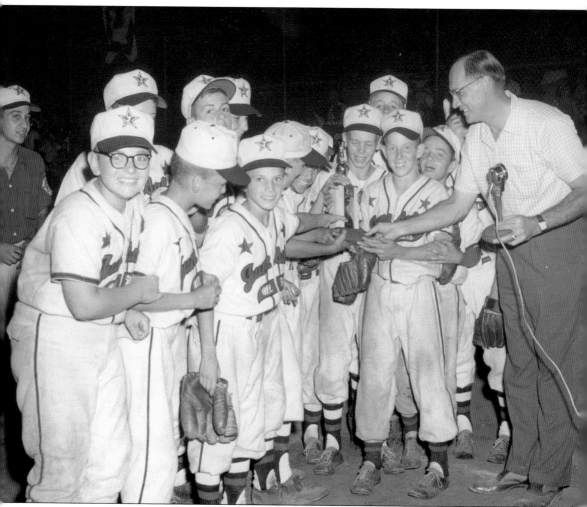

Pictured are the Junedale All-Stars being congratulated by Gary mayor Thomas Fadell. Every politician knew that being at a community event meant good public relations, and perhaps a few votes.

Little League games for the District I Tournament were transmitted to radio listeners through WWCA Radio in Gary. During the Senior Little League Games, WGN-TV of Chicago televised the championship game. Pictured is the radio announcer in 1953.

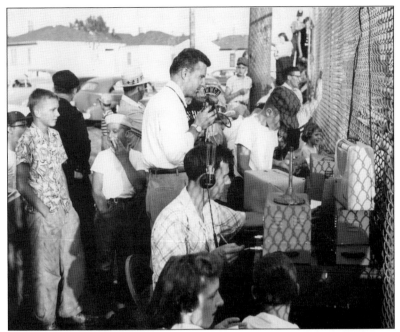

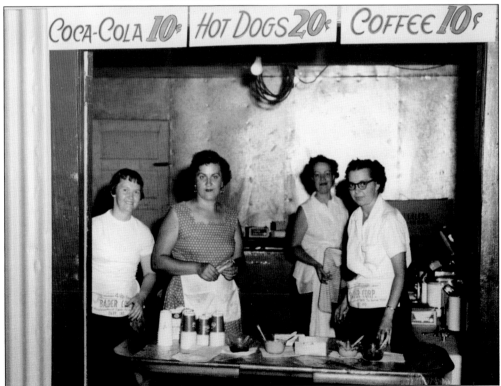

One important group of people involved in making the event run smoothly was the concession stand workers. Sometimes overlooked, these men and women volunteers made sure that the drinks were cold and the foods were ready for the paying customers. Pictured are some of the ladies who gave their time to make the event a success.

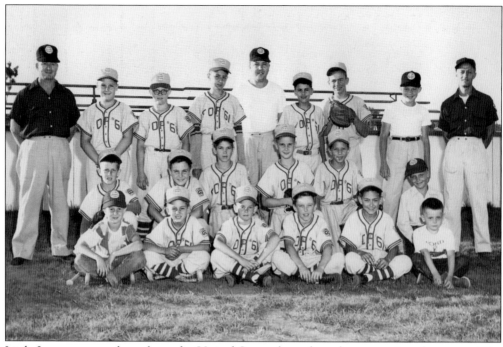

Little League teams throughout the United States depend on the generosity of sponsors. The Glen Park teams were no exception. Teams were backed by local stores, lodges, and auto-related businesses. Pictured is the 1954 FOP team, sponsored by the local Fraternal Order of Police.

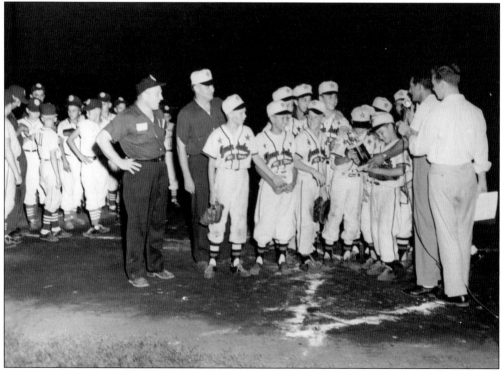

Here, players in the 1955 all-star game receive their awards.

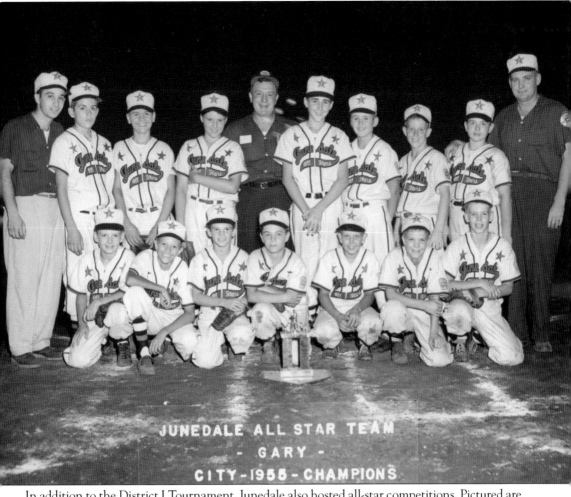

In addition to the District I Tournament, Junedale also hosted all-star competitions. Pictured are the Junedale All-Stars of 1955.

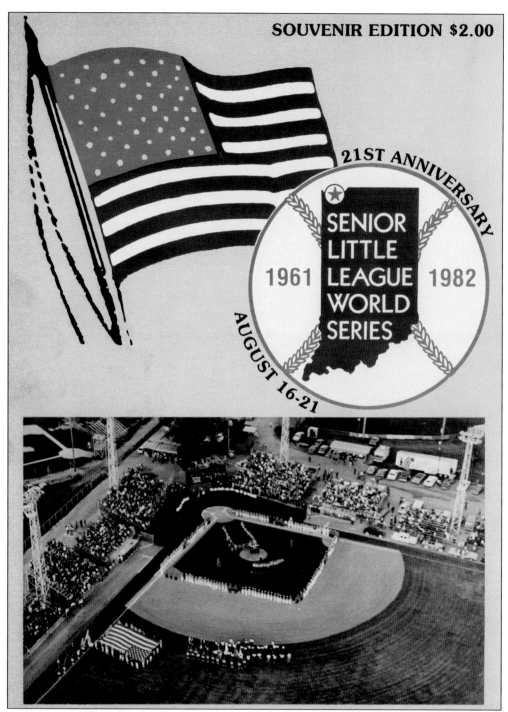

21ST ANNIVERSARY

SENIOR
LITTLE
1961 LEAGUE 1982
WORLD
SERIES

AUGUST 16-21

For 10 years, Gary held the title of Senior Little League Capital of the World, thanks to the dedicated work of Joe Eckert. Teams from all over the world competed for the Little League title at Junedale Field, at Fiftieth and Madison Avenues. Starting in the early 1950s, Junedale was also the home of the District I Tournament. Pictured is the 21st anniversary program in 1982.

Five

INDIANA UNIVERSITY NORTHWEST

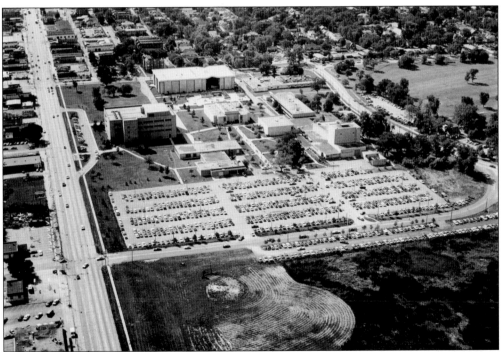

After World War II, millions of returning veterans had the opportunity to earn college degrees through the GI Bill. Purdue University established a regional campus in the area, while Indiana University offered classes in Gary. The early Gary Center for Indiana University offered classes at the City Methodist Church, at Sixth Avenue and Washington Street. By the late 1950s, Indiana University Northwest (IUN) had opened its present campus at 3400 Broadway in Glen Park. Over the next 50 years, the campus expanded to meet the demands of the growing student body. Pictured is an aerial photograph taken in 1980.

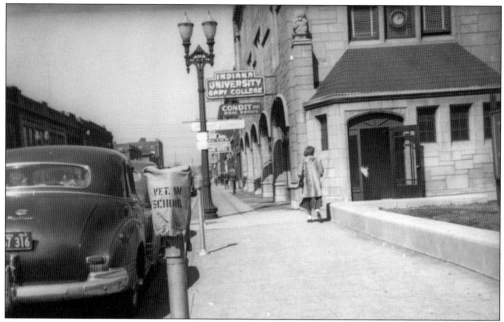

To serve the great number of returning veterans who would go to school on the GI Bill, Indiana University offered a number of classes in Gary. In the late 1940s, the City Methodist Church offered space at its facility. Pictured is the 600 block of Washington Street, where classes were held. Note that the cover over the meter says, "Vet. in school." Parking was limited, so veterans were given a pass to avoid a ticket.

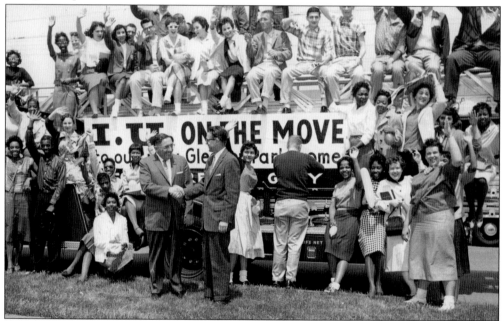

In 1956, the move to a new campus was announced before a public gathering of students, faculty, and invited dignitaries. The crowd was enthusiastic as 10 officials informed those present that construction plans were underway and that work on the new campus in Glen Park was planned for the following year.

Indiana University Northwest's first chancellor, Dr. John C. Buhner, is shown here in 1959.

On August 29, 1957, the groundbreaking ceremonies took place before crowds of over 300 people at the new site of the campus. Pictured here are Mayor Tom Fadell, at right, and the new chancellor, John C. Buhner, on stage.

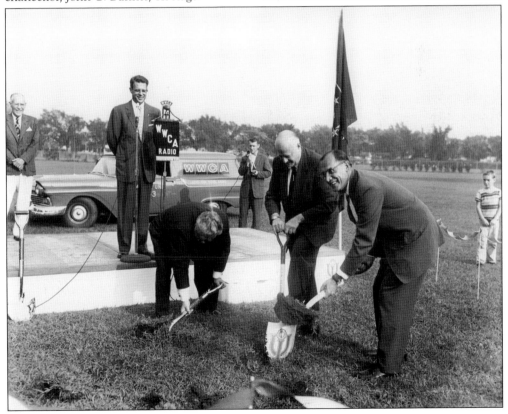

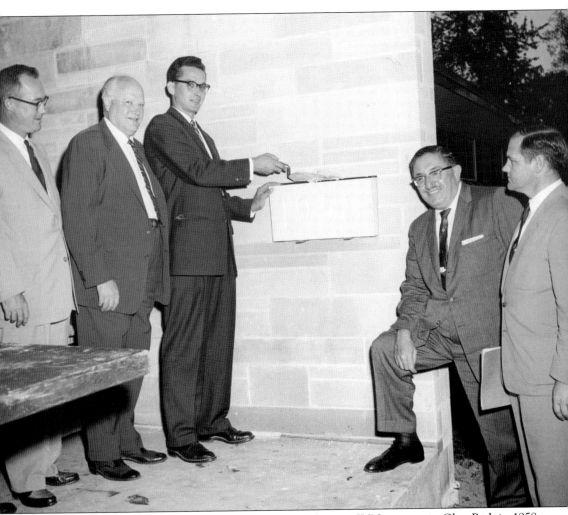

The cornerstone was laid for the main building for the new IUN campus in Glen Park in 1958. Pictured here at Tamarack Hall are the new chancellor, John C. Buhner, at center, and future mayor George Chacharis, second from right.

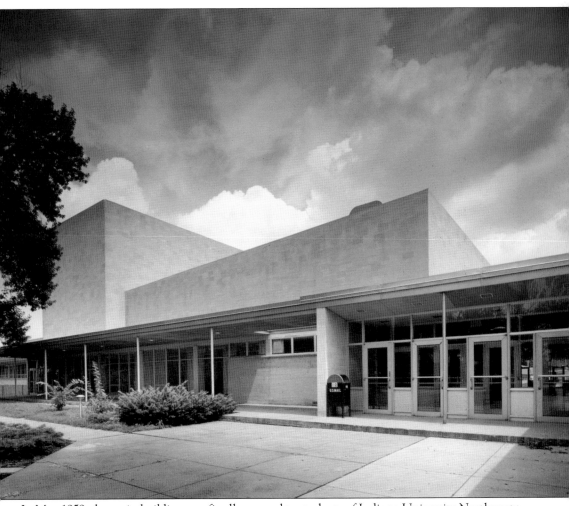

In May 1959, the main building was finally opened to students of Indiana University Northwest. The new structure contained classrooms, faculty offices, lecture halls, and a cafeteria. A library and a bookstore were on the ground floor. On the north end, a modern auditorium was part of the new building.

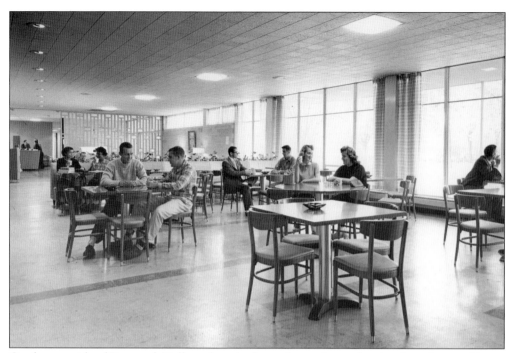

On the west side of Tamarack Hall, students had use of a spacious cafeteria where they could stop for coffee, a meal, and, of course, a few moments with classmates. The cafeteria was welcomed by the evening students, who had to rush from their day jobs in the area and had limited time for a hot meal.

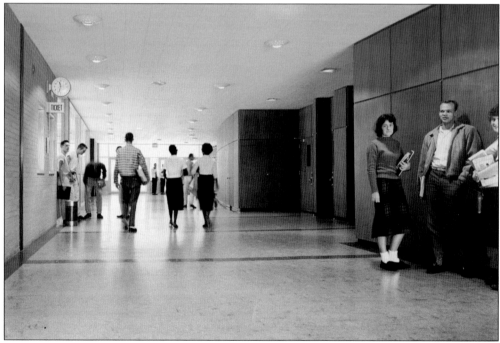

Pictured is the main lobby of Tamarack in 1959. The bookstore was located at the right of the photograph, near the three students. Just past the group were the entrances to the auditorium.

Many of the day students were taking a full load of 12 hours of classes each semester. After a full day of classes, they needed a break to just sit and relax in a lounge area or even in the cafeteria. Students are shown here enjoying some downtime.

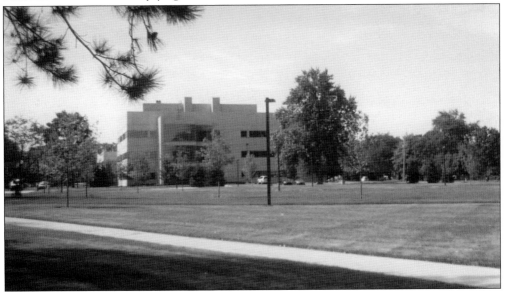

In 2008, the Glen Park area was hit by severe flooding following a terrible rainstorm. The Little Calumet River, just north of the campus, flooded the entire area, causing damage to many homes and parts of the campus. Tamarack Hall suffered extensive damage that closed it permanently. The green space pictured is where the building used to be. (Author's collection.)

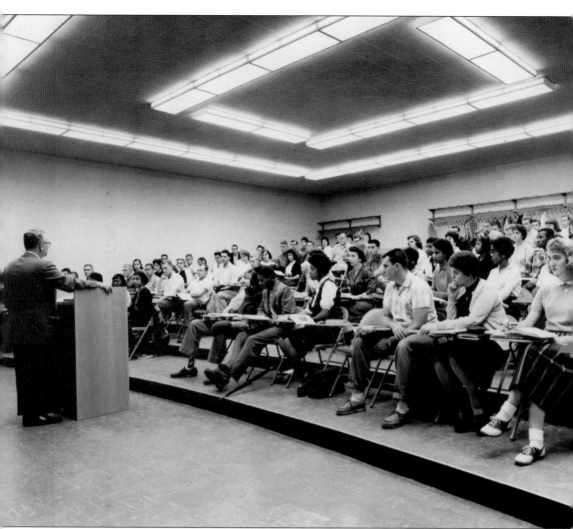

A typical classroom in Tamarack Hall is pictured in 1959. Students simply listened and took notes as the professor lectured and probably used the chalkboard and wall maps or diagrams. Laptops, power points, and smart boards were years away. Of course, there are still some old-school professors today who refuse to use new technology.

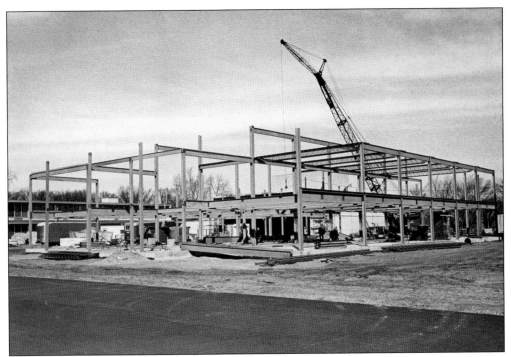

Indiana University Northwest underwent a major expansion of the campus, starting in the late 1960s with the addition of new buildings. Raintree Hall is seen here under construction, as workers lay its foundation.

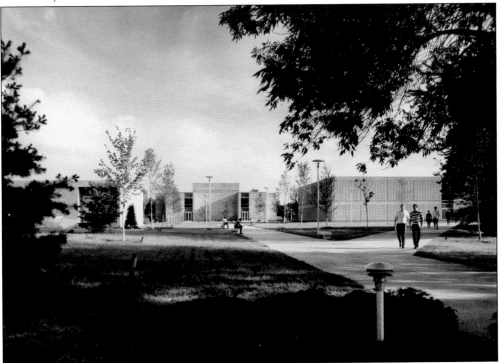

Raintree Hall is seen here soon after its completion.

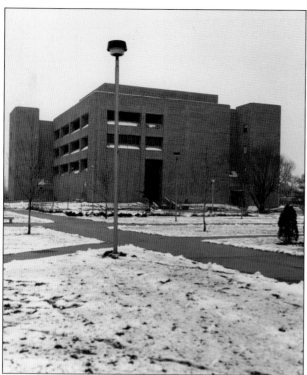

A new period of expansion at IUN took place in the 1980s along Broadway. Hawthorn Hall was added, providing more classroom space and offices as well as new lecture halls. The building changed its appearance a few years ago, as the redbrick exterior did not match the limestone style of the rest of the campus.

The original fine arts building was located on the east side of Broadway in the 1970s. Later, the department moved to its present location on the main section of the campus. The original building was unique in its style and caught people's attention.

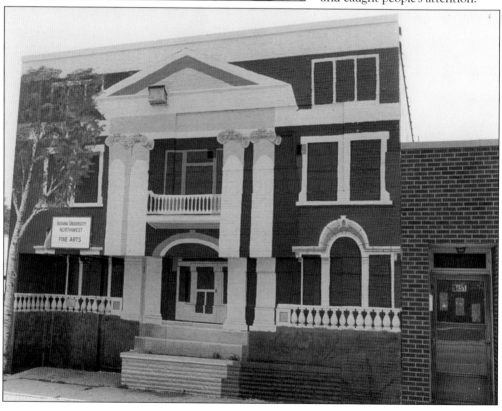

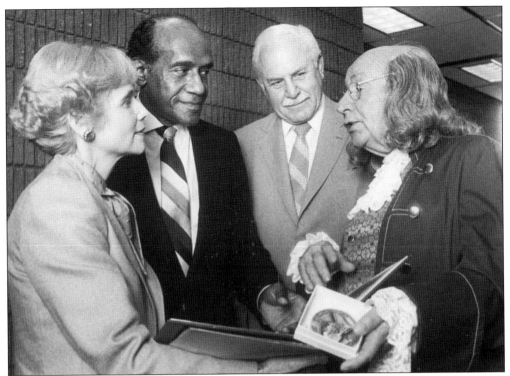

Chancellor Peggy Elliot is shown here with officials and old Benjamin Franklin. It was part of an event presented by the history and political science departments. A historical reenactor played Franklin.

Tom Higgins (left) was a longtime radio personality on WWCA Radio in Gary. The Horace Mann High School and Indiana University graduate is seen here with the "Miller Lite guy" at IUN.

Students faced a hectic week before semester classes began. They had to see the counselor, get the approval of the department head, and then rush to the registrar's office to get final approval. Often, students found out that certain classes were closed.

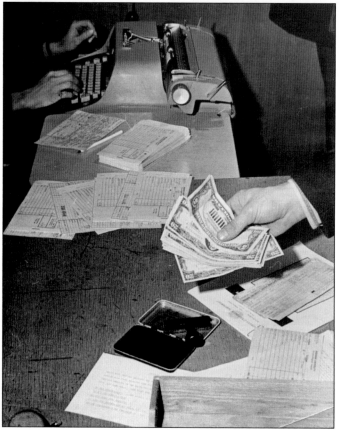

Once the student had his schedule approved, the final part of the registration process took place: payment to the school for classes and fees. In this 1982 photograph, cash was still the way to pay.

Indiana University Northwest had plans to build a medical school at its regional campus for a number of years. The university purchased the apartments at Thirty-fifth Avenue and Washington Street in the early 1990s to house medical students. However, the plans were changed, and the building was later torn down.

During the expansion period of the late 1960s, the university built the Moraine Student Center across from Tamarack Hall. It is pictured here in the late 1970s.

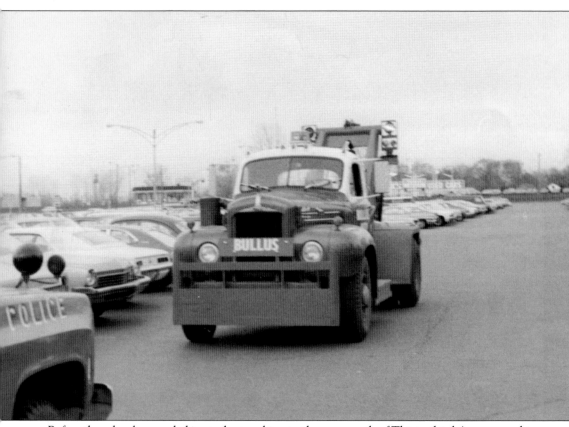

Before the school expanded its student parking to the area north of Thirty-third Avenue, parking was often a mess. Any open space outside the regular parking area was grabbed quickly. And, of course, the university police could ticket anyone without the proper sticker. Cars could also be towed. Bullus Towing often handled such matters.

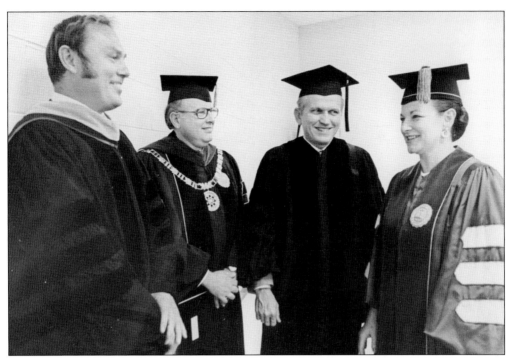

In the 1970s, Frank Borman, formerly of Gary, was the commencement speaker for IUN. As a NASA astronaut, Borman commanded the Apollo mission that orbited the moon on December 24, 1968. Few can forget that as they orbited the lunar surface that Christmas Eve, Borman read from the Book of Genesis. Later, he served as the head of Eastern Airlines.

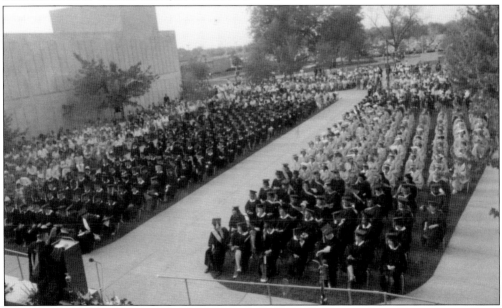

Indiana University Northwest held its graduation exercises at a number of locations in Gary. Gary West Side High School, Lew Wallace High School, and the Genesis Center were some that were used. Pictured is a shot of the 1982 event, which was held on the campus green space. Hopefully, the weather cooperated.

A place to stop within walking distance of the campus for a cup of coffee or a meal was Jennie's Café, located just across Broadway. It was popular with students and faculty. It is shown here in the 1970s, but it is no longer in business.

Six

Lew Wallace High School

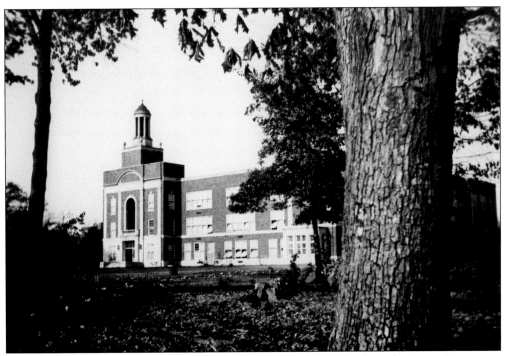

In the 1920s, the steel industry experienced a construction boom that brought in new investment and jobs. The downtown added buildings such as the Hotel Gary, the Knights of Columbus, and Memorial Auditorium. Glen Park saw the addition of a modern high school on West Forty-fifth Avenue: Lew Wallace High School. It is pictured here from the main entrance on the south side in 1930.

Lew Wallace High School was named after the famous Civil War general, governor of the New Mexico Territory, and author. It was Wallace who ordered the capture of the outlaw William "Billy the Kid" Bonney in the 1880s, and then Sheriff Pat Garrett gunned down the Kid. Wallace was also the author of the novel *Ben-Hur*.

The first principal of Lew Wallace School when it opened its school year in 1926 was Verna M. Hoke. She was a graduate of the University of Southern California. In the early years of the Gary Public School System, many of the administrators and teachers came to Gary from some of the finest schools in the nation, such as Northwestern, the University of Chicago, the University of Southern California, as well as state schools such as Indiana University and Purdue.

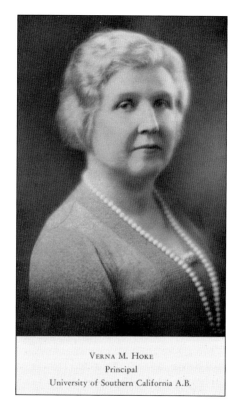

VERNA M. HOKE
Principal
University of Southern California A.B.

Feb. 17, 1926

Dear Miss Martin,

I wish to thank you in person for the honor to the memory of my grandfather, Gen. Lew Wallace, in naming your school in Gary the Lew Wallace School. My only regret is that my father, Henry Lane Wallace, did not himself receive your letter of January twenty-second, but he died very suddenly on January ninth while visiting us over the christmas holidays.

Although General Wallace died in 1905 I remember him very distinctly, and he was as you said a polished, courteous, chivalrous type of Indiana gentleman. His life and what he accomplished would make an ideal worthy of any child's ambition.

We deeply appreciate your thought of him, and the honor to his family.

Sincerely yours,

Lew Wallace Jr.

Throughout the nation, public buildings, schools, and roads are named after historical figures, war heroes, and distinguished local figures. In appreciation for the Glen Park school being named in honor of his father, Lew Wallace Jr. sent a handwritten letter personally thanking the school and the community.

In its early days, Lew Wallace served students from kindergarten through 12th grade. Later, as new elementary schools were added in Glen Park, the buildings were home to the junior and senior high school students. Pictured is the elementary building in the 1930s.

Gym class and extra-curricular activities were important parts of Gary superintendent Dr. William Wirt's work, study, and play program in the Gary Public School System. Here, the junior gym class takes part in a supervised activity in the 1930s.

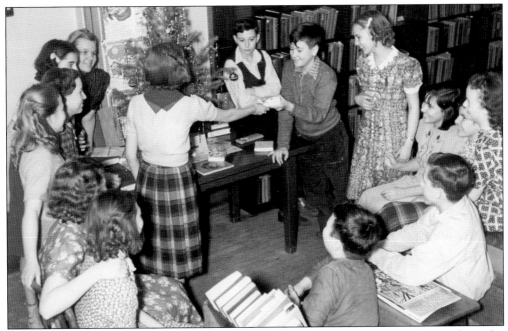

To promote reading at the school, the junior high had a library club. Members discussed popular books of the day as well as various classics. They spread the word to fellow students by hanging posters in school, raising money for new library books, and encouraging all to read more. The club members are pictured here around 1937 at their Christmas party.

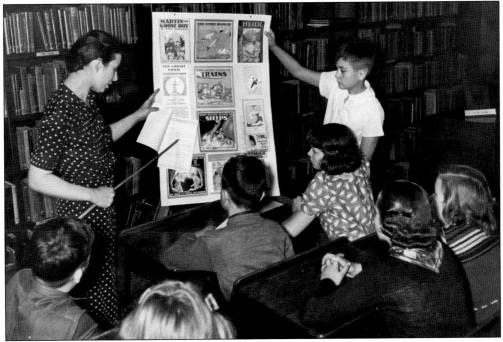

Junior high students were required to read a number of assigned books in preparation for high school at Lew Wallace. It was part of the Gary school curriculum guidelines required of all students. Here, students go over a required reading list.

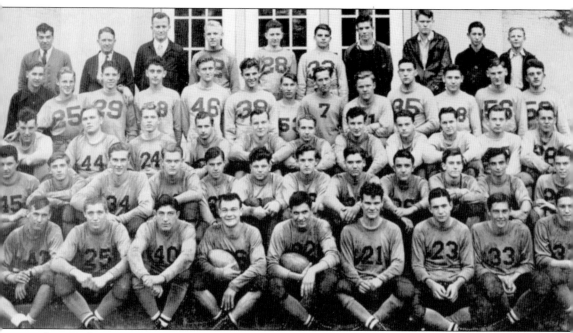

Lew Wallace enjoyed tremendous success in its football program from the 1930s through the 1960s. In 1941, the squad went undefeated with a 9-0 record under coach Chuck Baer. That year, they won the Northern Indiana Conference (NIC) title and the mythical state title. A playoff system was not yet in place. In 1940, they lost one game but still won the NIC West title.

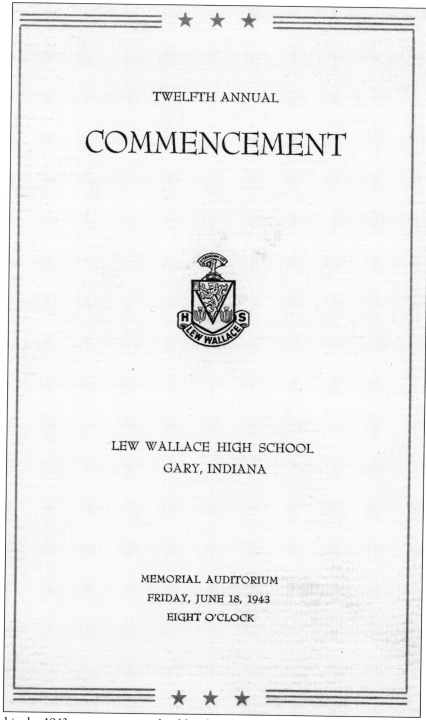

TWELFTH ANNUAL

COMMENCEMENT

LEW WALLACE HIGH SCHOOL
GARY, INDIANA

MEMORIAL AUDITORIUM
FRIDAY, JUNE 18, 1943
EIGHT O'CLOCK

Pictured is the 1943 commencement booklet that was presented to parents and students at the graduation exercises at Gary's Memorial Auditorium, at Seventh Avenue and Massachusetts Street. The date was June 18, 1943, and World War II still raged. However, the tide of war in Europe was turning, and the allies invaded France a year later on June 6.

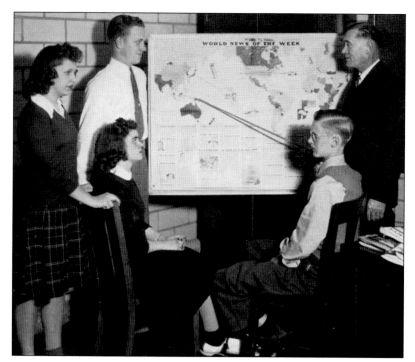

As the world situation grew worse by the day, many youngsters in school were just beginning to really pay attention to the news from overseas. For the past 10 years, the most important issues dealt with economic recovery and the Depression. Here, students follow the events of Europe and the Pacific in 1941.

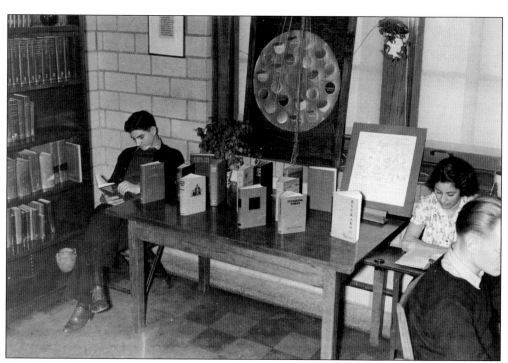

Junior high school students look over some of the assigned readings required to begin high school. In the 1930s, books were popular, as students did not face the distractions they do today.

THIRTEENTH ANNUAL

BACCALAUREATE SERVICE

1944

LEW WALLACE HIGH SCHOOL

GARY, INDIANA

LEW WALLACE AUDITORIUM

SUNDAY, JUNE 11, 1944

THREE O'CLOCK

Unlike today, baccalaureate services were included in the graduation exercises in the public schools. In 1944, America was at war, and many families had family members and friends serving in the armed forces in the theaters of action. In addition, five days earlier, on June 6, 1944, known forever as D-Day, the greatest invasion in modern history had taken place, as the Allies had opened a second front in France.

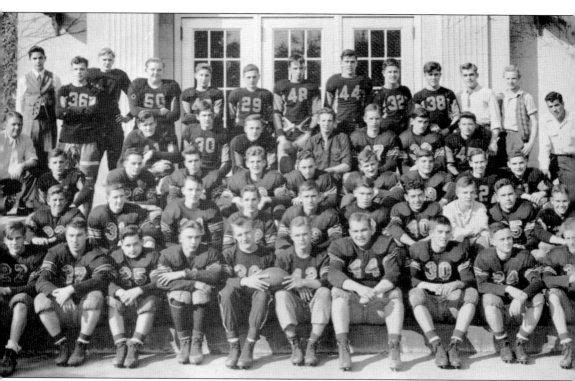

High hopes and expectations greeted the Lew Wallace football team in 1942. After an undefeated season and a state title the previous year, the pressure was on the defending state champions. Everyone wanted a shot at the team. An unblemished record was not in the stars that year, but the Hornets still had a winning record.

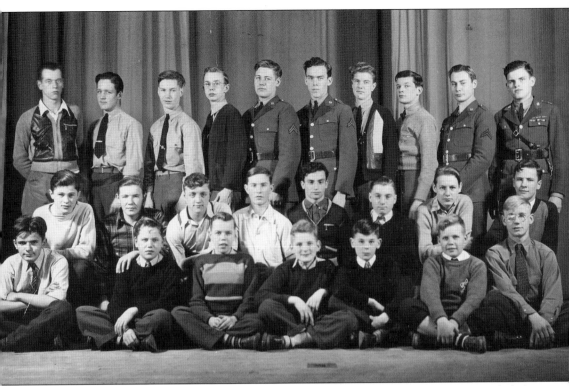

Part of the educational curriculum established by Gary superintendent Dr. William Wirt included auditorium class. Pictured is the 1943 class of Mrs. Hansz. In the back row, upperclassmen are shown in their Reserve Officers' Training Corps (ROTC) uniforms. Military science attracted many young men who wanted to one day do their part and support the war effort.

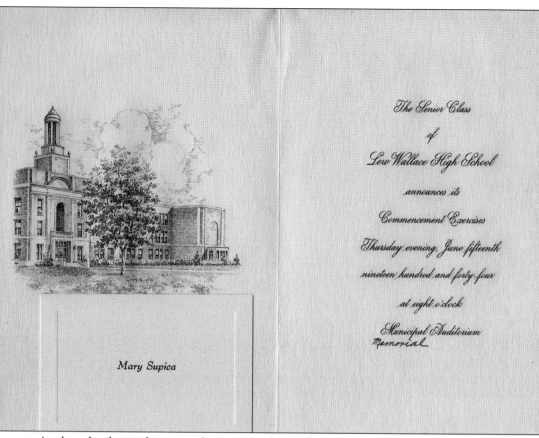

The Senior Class

of

Lew Wallace High School

announces its

Commencement Exercises

Thursday evening, June fifteenth

nineteen hundred and forty-four

at eight o'clock

Municipal Auditorium
Memorial

Mary Supica

As the school year drew to a close, seniors knew that their time at Lew Wallace was almost over. Events such as their last prom, getting their caps and gowns, and picking up graduation announcements made them realize they would be sent off to make their own way in the world. This is the graduation announcement of Mary Supica.

Lew Wallace High School

Gary ~ Indiana

This Certifies That

Mary Supica

has satisfactorily completed the Course of Study prescribed by the

Board of Education for the High School and is therefore entitled to this

Diploma

Given at Gary, Indiana

June 15, 1944

Verna M. Hoke
PRINCIPAL

Charles D. Lutz
SUPERINTENDENT

Edward T. Doyne
Loyd F. Burgess
Edith E. Norman
Boyce A. Bowen
Michael J. Lobo

BOARD OF TRUSTEES

After four years at Lew Wallace, Mary Supica and her classmates received their diplomas on June 15, 1944. Even though the nation was still at war, that night was filled with much promise and hope for Supica and her fellow graduates.

Salvatore Bushemi served as a Marine in the Pacific theater during World War II. He is pictured here somewhere in that theater of action in early 1944. Lew Wallace High School had a Wall of Honor that listed the many alumni who were serving in the European and Pacific theaters of war. It was to remind students of the sacrifices of the men and women graduates called to duty during the conflict. Pictured on the following pages are four of those who served.

Ben Kerr, a graduate of the class of 1941, is seen here as a young man in his early 20s. He took part in the air war during World War II.

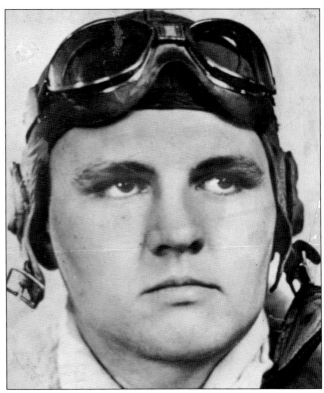

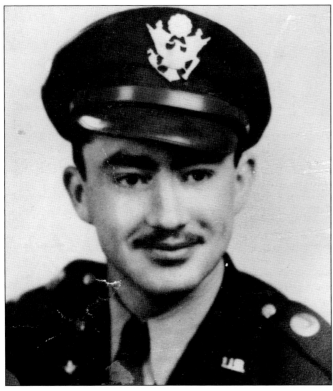

John Adler, a graduate of the class of 1938, answered the nation's call to duty and served in the Army.

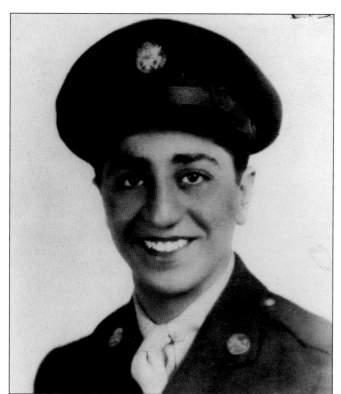

Sam Lazar, class of 1943, entered the military soon after graduation from Lew Wallace High School and served the nation in the US Army Air Corps. He was not yet 21.

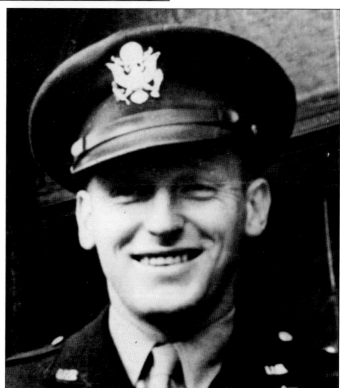

William Sablotny, class of 1939, served the nation honorably as a member of the Army.

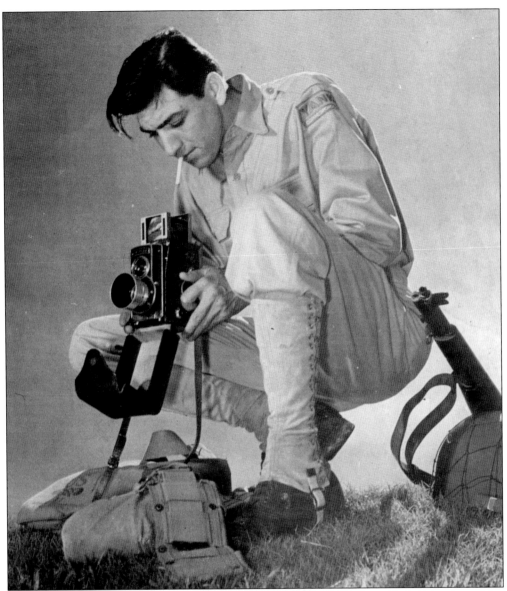

John A. Bushemi, Salvatore Bushemi's brother, attended Lew Wallace High School until his junior year. With the Depression, he quit to work in the mills where his father and brothers were employed. Hired by the *Post-Tribune* in 1936 as an apprentice photographer, his talents with the camera earned him the nickname "One Shot," because of his ability to get the right action photograph the first time. In 1941, he enlisted, went to boot camp at Fort Bragg, and was appointed official photographer. Sent to the Pacific theater in 1942, he covered combat in New Georgia, the Solomon Islands, and the Marshall Islands. For his work covering the action, he received numerous recognitions. While covering the news at Eniwetok Atoll in 1944, he was mortally wounded by a Japanese motor shell. His last words before he died showed his dedication. He said, "Make sure those pictures get back to the office right away." He was posthumously awarded the Purple Heart and the Bronze Star.

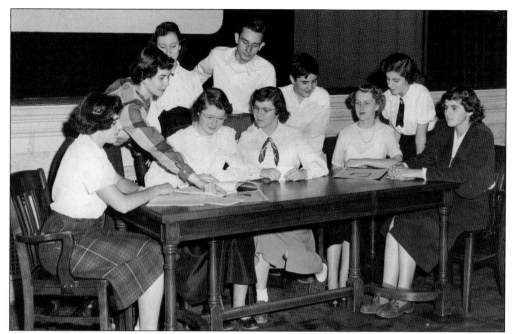

Included in the Gary Public School System curriculum was the requirement that one semester of speech class be taken before graduation. The course was usually offered in a student's sophomore year. Students are pictured preparing their topics in the late 1940s.

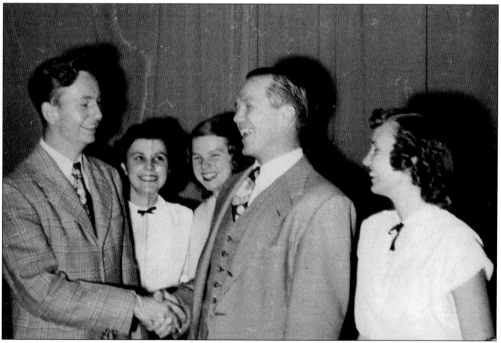

Gary's own Tony Zale, the "Man of Steel," returned to his hometown after his victory over Rocky Graziano for the middleweight title. He is pictured visiting Lew Wallace High School in the late 1940s. On that visit to his hometown, he was given the key to the city and a parade down Broadway.

Teachers at Lew Wallace had guided students through some challenging times, including the end of the Depression, World War II, and the postwar era. They taught students to be responsible citizens and to be prepared for life after graduation. Pictured are the faculty members just after the war. Their clothing styles are classic.

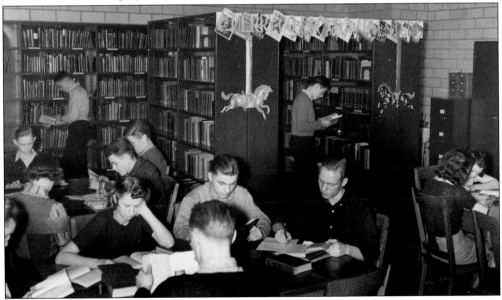

Every high school that was built in the Steel City included support facilities that gave students a well-rounded education. These included physical education areas, music rooms, auditoriums, shop classes, and a library area. Pictured is the library at Lew Wallace in 1950.

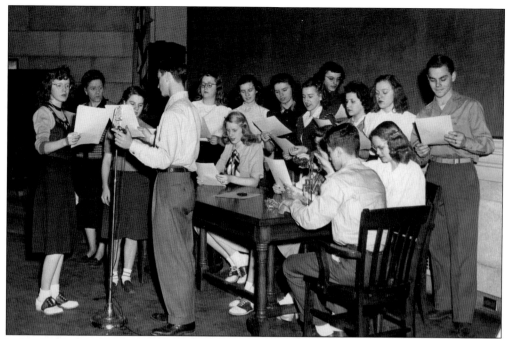

In the 1940s, Lew Wallace High School, with the assistance of the Gary Public School System, began to transmit local radio shows with students in charge of the programming. The station was WGVE-AM. Here, students are involved in an actual live broadcast.

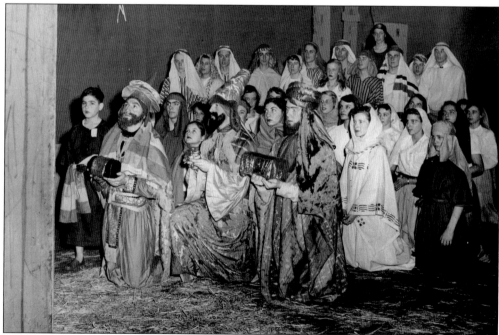

Annual Christmas programs were common in the Gary public schools before the more recent emphasis on political correctness. Schools were decorated with lights, garland, and even Nativity scenes. The holiday break was called Christmas vacation. In this 1947 photograph, Lew Wallace students take part in the true meaning of Christmas.

Just as they do today, young people of the 1950s enjoyed listening to the latest music from the popular singers of the era. Unlike today, they listened to 45 rpm and 33 rpm records. These vinyl relics were played on record players, and stereo sound was not even available. Here, Wallace teens listen to the likes of Paul Anka and Bobby Darin.

In 1966, under coach Eddie Herbert, Lew Wallace High School went 10-0, winning the Northwest Conference championship. In the playoff, they faced East Chicago's Roosevelt Rough Riders to cap an undefeated season. They earned a No. 2 ranking in the final state poll.

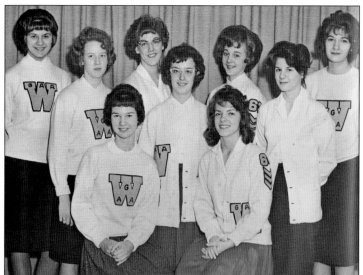

The Girls Athletic Association (GAA) was an organization open to young ladies at Lew Wallace that encouraged them to take part in athletics. However, the members also worked to raise money for school programs. They held car washes, sold tickets for raffles, and had bake sales. The group also sponsored dances such as the turnabout each year. Pictured is the GAA council in 1963.

For a young lady to be a cheerleader, a great deal of work was involved. A girl had to be fit, know the cheers, and be able to get up and try again if she fell. A committee of teachers and senior members of the squad made the decisions about who would qualify to be on the team. Pictured are the varsity members of the Lew Wallace Hornets cheering squad.

Christ Christoff served as the principal of Lew Wallace in the 1970s. He was a teacher at Emerson High School in the 1960s, then the principal at Froebel, his alma mater, and the vice principal at West Side. He is pictured here in 1970.

Girls' athletics experienced tremendous growth in the 1970s throughout the region. More programs were now available for girls to take part in. Here, softball player Diane Sanchez goes over game plans with her coach around 1980.

HANK STRAM HEAD COACH KANSAS CITY CHIEFS

Hank Stram was a graduate of Lew Wallace High School. He coached the Kansas City Chiefs in the first Super Bowl, against the Green Bay Packers, in 1967. Though the Chiefs lost 33-14, two years later, they came back and gained a convincing win over the Minnesota Vikings.

Like the other high schools in the region, Lew Wallace had its own song calling for loyalty to the school's name. Graduates who went on with their lives and became successful or served in times of conflict did just that.

Lew Wallace Song

Hail to Lew Wallace,

Fight on for her fame;

Keep her colors flying,

Glorify her name;

U-Rah-Rah!

We're loyal, Lew Wallace,

To us you'll e'er be dear,

And to your colors of black and gold,

Cheer, Lew Wallace, Cheer!

In 1967, the class of 1933 got together for its 34th class reunion. The classmates shared fond memories of their experiences at Wallace and had plenty of stories to tell of their lives after graduation. This group went through the difficult days of the Great Depression and the challenging times of World War II. They were part of America's Greatest Generation.

Pictured is the Lew Wallace class of 1947 at its 20-year reunion in 1967. While 20 years may have gone by, at the reunion, those old school days likely felt like only yesterday to them.

Pictured is the class of 1947 at its 30-year reunion in 1977. Besides sharing old school memories, they compared experiences being parents, and, for some, becoming grandparents.

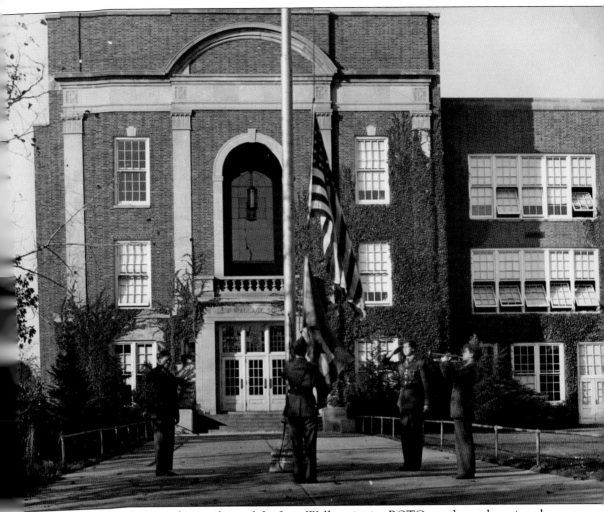

In this 1941 photograph, members of the Lew Wallace junior ROTC are shown lowering the colors at the end of the school day. It was a tradition at Gary for classes to stand in respect as the bugle sounded. For the schools like Lew Wallace that had an ROTC program, it was an honor to be selected for the ceremony. On their last school day, seniors stood and heard the bugle sound for the last time. For many of those graduates, the ceremony remained a cherished memory. It is the author's hope that this last photograph will once again renew many of those great memories that will be shared with fellow alumni, family, and friends. Happy fond memories!

DISCOVER THOUSANDS OF LOCAL HISTORY BOOKS FEATURING MILLIONS OF VINTAGE IMAGES

Arcadia Publishing, the leading local history publisher in the United States, is committed to making history accessible and meaningful through publishing books that celebrate and preserve the heritage of America's people and places.

Find more books like this at
www.arcadiapublishing.com

Search for your hometown history, your old stomping grounds, and even your favorite sports team.